THE
HUMAN FORM
IN MOSAIC

ELAINE M. GOODWIN

THE CROWOOD PRESS

First published in 2007 by
The Crowood Press Ltd
Ramsbury, Marlborough
Wiltshire SN8 2HR

www.crowood.com

**It is strongly recommended that ALL safety and security
measures are adhered to when creating mosaics. Protective
eye wear, dust protectors for the mouth and nose, and latex
or rubber gloves for the hands should be worn at all times
and in all cases.**

The author and the publisher do not accept any responsibility in any
manner whatsoever for any error, or omission, nor any loss, damage,
injury, adverse outcome, or liability of any kind incurred as a result of
the use of any of the information contained in this book, or reliance
upon it.

British Library Cataloguing-in-Publication Data
A catalogue record for this book is available from the British Library.

ISBN 978 1 86126 981 2

SHE, **1995, 100 × 100cm (39 × 39in), Elaine M. Goodwin, Carrara
marble, Venetian gold, smalti.**

DEDICATION

For my mother and my father
and my Auntie Lillian –
a sparkling tessera at 93

EMG

Typeset and designed by
D & N Publishing
Lowesden Business Park, Hungerford, Berkshire.

Printed and bound in China by 1010 Printing International Ltd.

CONTENTS

ACKNOWLEDGEMENTS

Photo credits: all the images are by Jules (Karen Taylor), except where indicated otherwise in the text. I wish to extend a big thank you to Jules for her many sparkling photographs and for her patience, erasing frequent coffee cup stains from the backing timber used for projects.

The artists' statements were translated (where necessary) and collated, with gracious consent from the artists, by the author, who apologizes for any subsequent loss of intention or integrity in the finished result.

I have relied heavily on the patience, selfless generosity, time and good-humoured support of Lindy Ayubi, who has once again digitized my increasingly sprawly handwritten scripts to allow publication. I thank her warmly.

I extend a grateful acknowledgement to Jane Clark, of the Institute of Arab and Islamic Studies, Exeter University, England, for her insightful indexing and proof-reading of this publication.

My sincere thanks go also to the following, who have, over the years, graciously permitted me to view, record or photograph works in their keeping, or who added their knowledge and inspiration to the making of this book:

Archaeological Museum, Barcelona, Spain; Archaeological Museum, Tetouan, Morocco; Bardo Museum, Tunis, Tunisia; Archaeological Museum, Sousse, Tunisia; Archaeological Museum, Gatsa, Tunisia; Museum of Naboul (Neapolis), Tunisia; Narlikuyu Museum, Silifke, Turkey; Archaeological Museum, Naples, Italy; Archaeological Museum, Aquileia, Italy; Archaeological Museum, Egnazia, Puglia, Italy; Archaeological Museum, Piazza Armerina, Casale, Sicily, Italy; Archaeological Museum, Ostia Antica, Italy; National Museum and Gallery, Capodimonte, Naples, Italy; Terme di Caracalla, Rome, Italy; Borghese Gallery, Rome, Italy; Archaeological Museum, Pella, Macedonia, Greece; Kunsthistorisches Museum, Vienna, Austria; Staatliche Kunsthalle, Karlsruhe, Germany; Städelsches Kunstinstitut, Frankfurt, Germany; Museum of London, England; Kingston-upon-Hull Museum, England; Somerset County Museum, Taunton, England; Dorset County Museum, Dorchester, England; Dr Aghilare and staff, Foro Italica, Rome, Italy; Barrie Pepper, and the vicar of St Aidan's Church, Leeds, England; Focal Point Exeter, England; Dr Mehmet Önal, archaeologist, Gaziantep Museum, Turkey; Aliye Özgur, Narlikuyu Muzesi, Turkey.

Lastly, to all my dear friends and colleagues who have supplied a new work for this publication to help inspire all of us – thank you.

PREFACE

'How can such hard stone and marble make such a
soft-looking moulding of the human form?'
'How do so few pebbles give such life and movement
to the nude figure?'
'How can I put such humour and character into
an unclothed figurative form?'

I have heard all these marvellings and laments when looking at figurative mosaics on my travels abroad and around England in the company of mosaicists and friends. This book is written as a direct response to these and other similar questions.

I have chosen to explore the portrayal of the figure using one method only throughout the book. This is defined as the 'direct' method – that is, a material is cut into smaller pieces called tesserae and applied *directly* onto a supporting or backing board. In this way, the maker is intimately and visually in dialogue with the new work as it evolves. This instantly satisfying procedure is uniformly applied to both the full figure projects and the portrait heads. I believe this will allow a deeper insight into the *modus operandi* used to interpret and elucidate the bodily form into that marvellous medium we call mosaic.

I hope to accompany you in thought and word as you unravel some answers to the questions posed above.

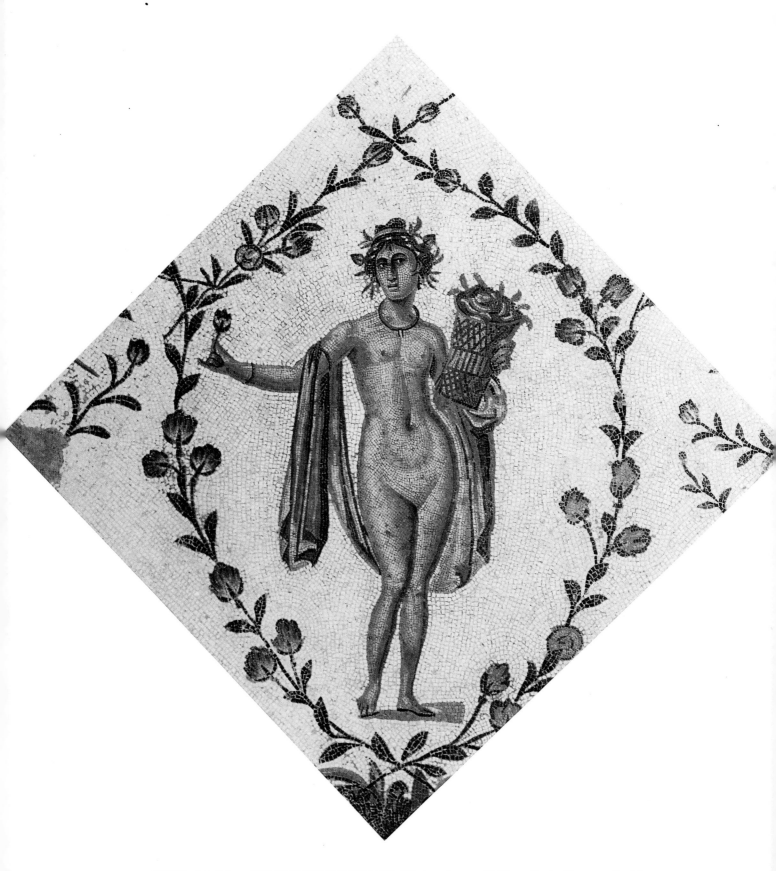

SPRING, **detail from** NEPTUNE AND THE SEASONS, **third century** CE, **El Djem, Bardo Museum, Tunisia.**
Photo: Elaine M. Goodwin

INTRODUCTION

The unclothed figure in mosaic is one of extreme fascination, transporting the viewer into a reverie of imagination. Male and female figures appear with delightful frequency in ancient pagan mosaics to illustrate scenes from classical mythology, but few modern mosaicists have explored this avenue of expression for themselves. This book aims to redress this omission and entice the practitioner to enter into a long-forgotten figurative tradition.

EVE, **detail from** ADAM AND EVE **by W. B. Richmond, attic entablature, St Paul's Cathedral, London, England,** *c.*1896
(identical copy: Museum of London, *c.*1896).
Photo: Elaine M. Goodwin

Around the Mediterranean, between the fifth century BCE and the sixth century CE, it is easy to imagine Ancient Greek and Roman villa owners, as well as the surrounding citizens, enjoying the nude figures depicted on the many superbly illustrated mosaic floors in their sumptuous homes or communal bath houses. The people of that time delighted in great freedom of visual sensual expression as a part of their natural way of life.

Later, with the emergence of Christianity and the Byzantine era, the cupolas and nave walls of the new religious buildings were adorned with narrative outpourings. Central to the pictorial story telling was the creation story; specifically, the story of Adam and Eve. Their portrayal as unclothed figures in the Garden of Eden continued only until their loss of innocence, that is, when their nudity became nakedness. From that point, all figures in religious iconography appeared clothed or without sensual overtones, for example the *pieta*, consisting of the Virgin Mary holding the crucified Jesus.

There then followed a period of little mosaic activity. Even during the Renaissance, when the nude figure was re-evaluated, with artists looking back to ancient pagan times for inspiration for their painting and sculpture, the art of mosaic was relegated to that of picture copying. When there was eventually a revival of mosaic activity on the Continent in the mid-nineteenth century and the Victorian era in Britain, mosaics of unclothed or semi-clad figures were few and far between, and although the mosaics by W. B. Richmond in St Paul's Cathedral in London feature a wondrously nude Eve and Adam, seated among beasts and birds, they appear so high on the choir walls as to be almost out of sight.

In the twentieth century, there was no true celebration of the nude figure in mosaic, except for a few singular and memorable

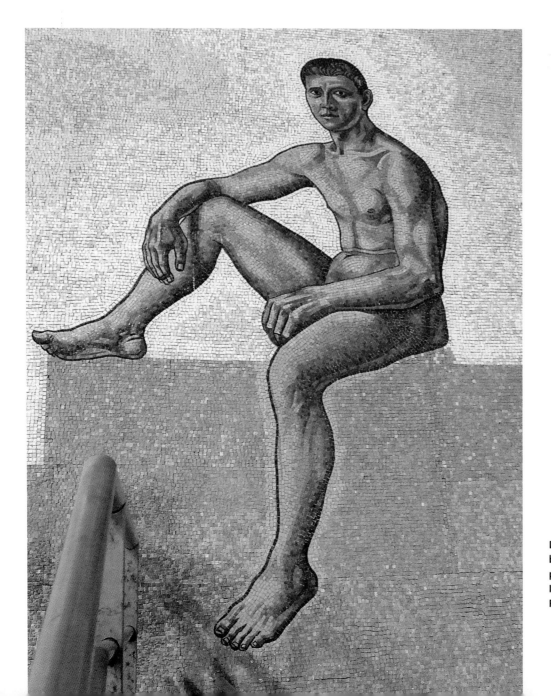

Detail from SEATED ATHLETE by Angelo Canevari, *c.*1935, piscina/swimming pool, Foro Italica, Rome, Italy. Photo: Elaine M. Goodwin

instances. In Italy, during the period of Fascism under Benito Mussolini, the athletic male form was celebrated in mosaic as a symbol of health and beauty, whether nude or sporting minimal clothing. Numerous depictions can be enjoyed at the swimming pool and athletic grounds of the Foro Italica in Rome, Italy, in black and white or in more naturalistic polychrome. They were designed by artists, including Angelo Canevari, Giulio Rossi and Gino Severini, and translated into mosaic by the creative interpreters at the mosaic school in Spilimbergo, Friuli, Italy.

Much mosaic created in the twentieth century and to date in the twenty-first century has a distinctly decorative or functional nature. This book hopes to reopen an interest for the present-day mosaicist in the art of figurative mosaic.

All the inspirational imagery for each project is taken from a mosaic from a previous period and is explored through techniques and materials. Since ancient times, there has been no consistent enquiry into the bodily form for present day artists to build on. By working through the projects, practitioners will build up a greater understanding and expertise as they begin their own real enquiry into how to modulate and express the figure in a tessellated form.

The first projects depicted within begin by exploring important mosaic figures predominantly from the classical pantheon. The manipulation of the tesserae, those small units of mosaic-making, are observed closely to give structural meaning to the unclothed torsos and forms.

The final projects concentrate on the face, both self-portraits and those of others close to me. Various techniques and differing materials are explored intimately. It will gradually emerge that mosaic is characteristically a very different medium from that of drawing, painting and sculpture, and that tesserae of glass, ceramic, stone and marble are uniquely different materials of expression compared to pencil, paint and clay.

In accumulating understanding of the specific potential of the medium of mosaic, artists and mosaicists will inevitably evolve their own personal ways of translating and expressing the figure. To illustrate this, I have asked nine leading practitioners of mosaic art, from a variety of countries, to join me in sharing and demonstrating an individual approach to interpreting the figure by each creating a new work for this book. I hope you will agree that what has been created is an exhilarating and enhancing result.

META, METAL, MORTAL by Elaine M. Goodwin, 2003, 61 × 61cm (24 × 24in), vitreous glass, marble, granite, Venetian blue gold.

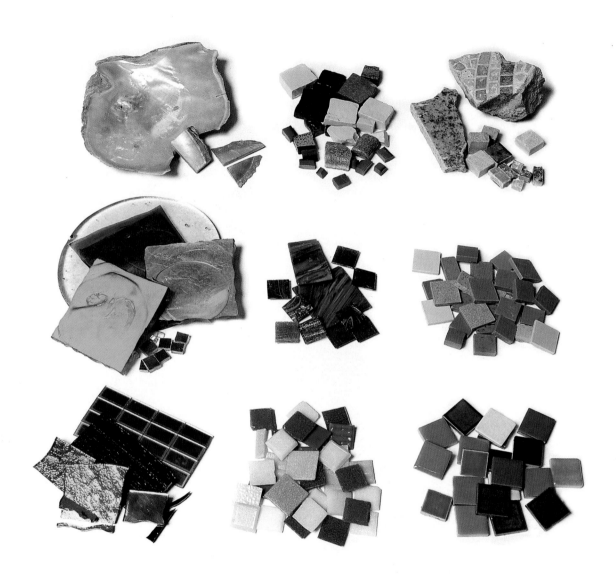

Materials: examples of the types of materials that will be used in this book.

THE PROJECTS – GETTING READY

Each project will take the practitioner through particular aspects of mosaic-making that relate significantly to a new work and its creation. In this way, aspects – such as drawing, light, texture and colour – will be able to be considered in depth alongside the making process.

Before Beginning – About the Materials

1	2	3
4	5	6
7	8	9

Key to materials (opposite).
1. mother of pearl
2. mosaic glass smalti – note their natural imperfections
3. various marbles, plus blue macauba, blue bahia and blue sodalite
4. Venetian metallic gold and gold leaf roundel
5. vitreous glass tiles with added copper dust for a sparkling effect
6. unglazed ceramic tiles
7. mirror tiles and Ravenna mirror glass
8. manufactured vitreous glass tiles
9. glazed ceramic tiles

The materials cut for use in mosaic are known as tesserae. The tessera is the unique building block of mosaic. By definition, it is a solid unit, often squarish but also frequently cut to shape by the artist for an exact purpose. The tesserae may be of natural stone, granite, marble or pebble, factory-manufactured glass or ceramic, handmade glass called smalti, or embedded metallic glass plates in gold, silver, copper or coloured finishes.

Each project in this book uses the direct method for laying the tesserae.* This involves cutting the tesserae and applying them to a plywood base. By standardizing the method of application throughout, concentration can be better centred on the anatomical modulation and the varying characteristics explored in each new mosaic.

Alongside the methods of cutting, the properties of each material will be explored and the limitations of each material will soon be realized. It is important from the outset never to deny these limiting factors within the medium of mosaic – a medium which is in essence an accumulative one, consisting of building up individual units of a durable material. This is the *true* characteristic of mosaic. At no time should mosaic become imitative of painting, or deny the singular identity of the materials used. Once the integrity of the tessera is understood and enjoyed, aspects such as colour, textural, light and spatial theories can all be examined to greater effect.

* In the indirect method, pieces are temporarily fixed top-side down onto a removable base material. This is then cast in its final form and the temporary base material removed to reveal the mosaic, top-side up.

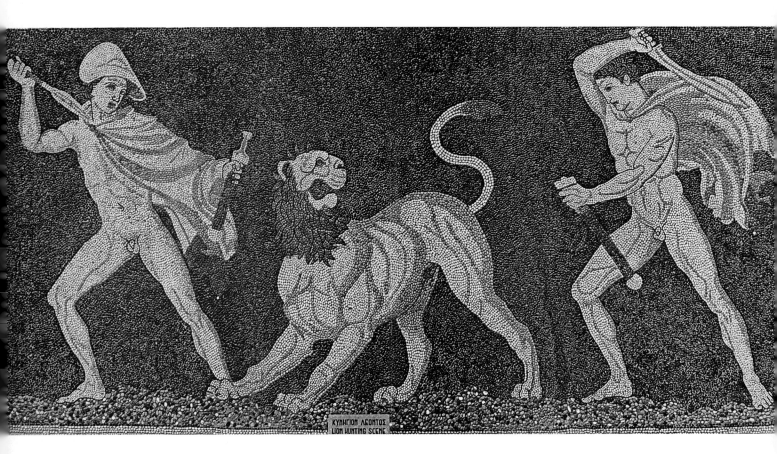

KYNHΓION ΛΕΟΝΤΟΣ
LION HUNTING SCENE

THE LION HUNT, central panel from an *andron* (men's banqueting room), House of Dionysos, *c.*325–300BCE,
Archaeological Museum, Pella, Macedonia, Greece.
Photo: Elaine M. Goodwin

PROJECT ONE –
THE LION-HUNTER

History

Energy in an unadorned figurative form is an uninhibited delight. The Greek pebble floor mosaics of Olynthos and Pella in ancient Macedonia illustrate superbly energetic male and female poses, including males in scenes of hunting and females enacting frenzied Bacchic dances and Amazonian heroics. Most accomplished are the heroic male forms, which are all the more remarkable as it is pebbles, not tesserae, which make up the forms. These are placed in such a way as to emphasize both internal anatomical structure and external silhouetted form. It is masterly.

Inspiration

Considering the restrictions of using pebbles, with their hard and unrelenting rounded form and natural limitations of colour, the mosaics of Pella are undeniable masterpieces. The artists have overcome these colour restrictions by use of subtle colour gradations.

For me, it is the pose of the nude male figure, striding forward with the right leg advanced and bent and the left leg straight behind, which captivates. It demonstrates two anatomical observances – the leg in profile and the leg in a frontal position. This singular pose is referred to by the great English art historian, Sir Kenneth Clark, as the 'heroic diagonal'. It is counterbalanced in this instance by the left arm, which is holding a scabbard, and the right arm, which is bent and positioned behind the head while holding a sword. The energy 'released' is powerful and overwhelming, exhibiting an extraordinary latent force, significantly all the more so as the pose is held in stones. Added motion is given to the image by the cloak, or *chlamys*, which wafts behind the figure, billowing in space.

Having viewed the actual mosaic, I am convinced that this superbly controlled mosaic depicts Alexander the Great of Macedonia (356–323BCE) alongside his fellow lion hunter and

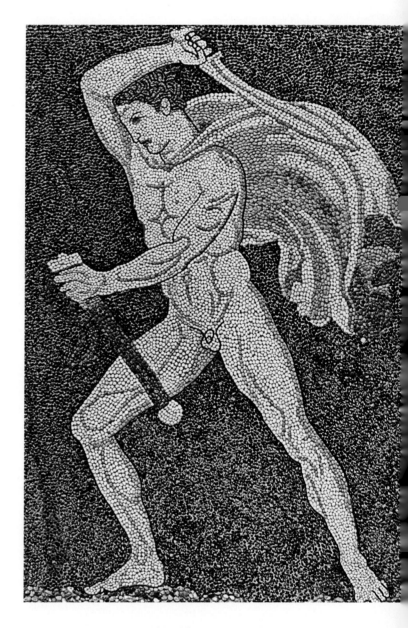

LION HUNTER, **detail from** *The Lion Hunt*,
from the House of Dionysos, *c.* **early fourth century** BCE,
Archaeological Museum, Pella, Macedonia, Greece.
Photo: Elaine M. Goodwin

friend, Krateros.* The strong profile, the forceful downward gaze and undulating hair, all depicted in the pebbles, are some of the attributes directly associated with any image of Alexander – here, a prototype in stone.

It is very probable that the ancient master mosaicist, Gnosis, was the creator of this work, as he was of others on the site at Pella. We know this from a work known as the *Stag Hunt*, a real tour de force, which has his signature writ large in the background – ΓΝΩΣΙΣ ΕΠΟΗΣΕΝ *(Gnosis made this)*.

Drawing

Materials

- ▓ 12 mm (¹/₂in) plywood backing board, suggested size 122 × 82cm (48 × 32in)
- ▓ pencil/crayon
- ▓ pointed felt-tipped pen/marker
- ▓ white paint and brush (optional)
- ▓ wooden figure model

It can be both fun and useful to purchase a jointed wooden figure model. Even the simplest and cheapest kind can give some understanding of the broad anatomical movement at the hips and shoulders, as well as the more limited movement of the knees and elbows. The proportions – although not too accurate – will help when drawing a pose.

When drawing the figure, be aware of a continuous diagonal line – upwards from the straight leg, right through the back and up to the shoulder. This pose has been repeated in artistic expressions throughout the centuries. The diagonal, by its very nature, imparts dynamism to a figure.

Translate the drawing to the backing board either by squaring up a photographic picture, or by drawing directly onto the timber by eye. Keep the drawing simple, concentrating on the dynamic diagonal thrust of the form. Transfer the simplified anatomical pebble markings into simplified pencil-drawn lines. When the drawing is completed to your satisfaction, use a felt-tipped pen to strengthen the image to make it easier to work on in cut tesserae.

I have painted the board white purely to show more clearly the outlining process in this project. This mosaic will be grouted and any hint of the backing colour or material will be hidden.

Application

Materials

- ▓ black vitreous glass
- ▓ ceramic tiles in white, black, blue, terracotta and grey
- ▓ wheeled glass mosaic cutters
- ▓ standard and heavy duty mosaic cutters
- ▓ standard mosaic nippers
- ▓ prodder/dental tool
- ▓ palette knife
- ▓ PVA/white glue and container

Although the contouring of the face and inner anatomical forms is composed of pebbles in the original, much of the outline figure contouring is 'drawn' with strips of black lead or occasional terracotta piping strips, burnt a black colour. They are of varying lengths and give great articulation to the silhouetted form. Use black glass tesserae in various sizes to imitate the lead piping. The slightly serpentine nature of the lengths can be achieved by applying extra pressure with the cutting hand when using the wheeled glass mosaic cutters. Glue the tesserae to the backing board by putting a little of the adhesive on the back of each using the palette knife.

The drawn image.

* Lion-hunting was a sport favoured by royalty and nobility. This mosaic could well depict a famous hunting scene that took place in Asia Minor at Granikos, where Krateros saved his close friend Alexander from an attack by a savage lion.

ABOVE: **Adding the terracotta colour to the design.**

RIGHT: **Delineating the muscles with grey ceramic tesserae.**

BELOW: **Cutting and laying the outline.**

My decision to use manufactured tesserae rather than natural pebbles was primarily a practical one, as pebbles of good tonal quality are hard to come by. Also the pebbles used at Pella were small, approximately 1cm (0.4in), and only occasionally cut to give a tighter tessellation. By using simply cut ceramic or terracotta tesserae, greater attention can be given to articulating the bodily form and interesting decisions on the direction of these tesserae will have to be made. It is worth mentioning that as none of the projects is a direct facsimile of the original, choosing ceramic tesserae instead of pebbles for the design allows not only for a greater degree of translation and enquiry into figurative tessellation, but also re-invents the pose.

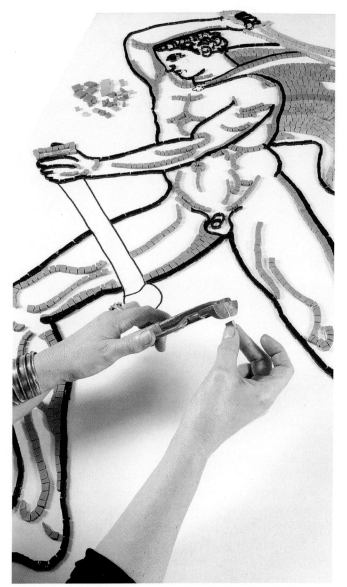

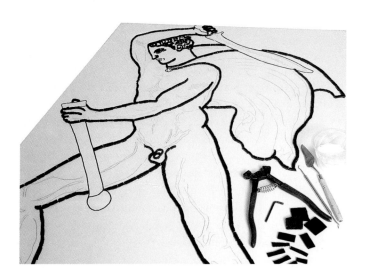

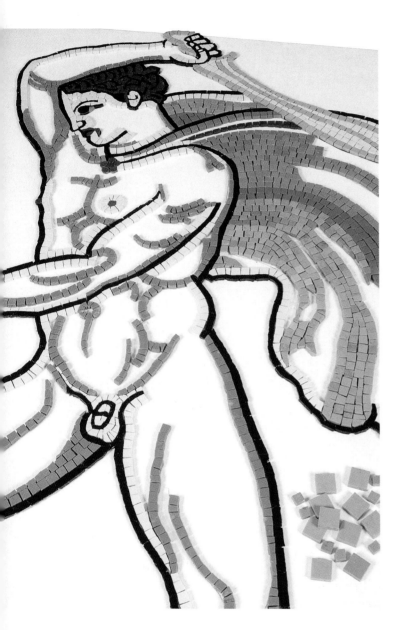

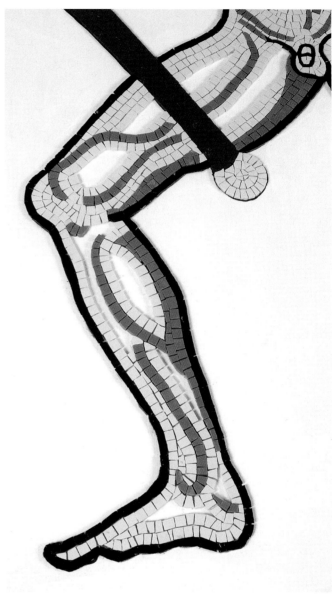

ABOVE LEFT: **Use the white tesserae to build up the form within the 'drawn' black lines.**

ABOVE RIGHT: **Detail of the leg, showing the gradual modulation of its structure.**

The muscles in this work are delineated simply, using a soft grey colour. These uniform lines give just enough information to the pose to keep it simple and striking – two adjectives to keep in the front of your mind when working in mosaic.

Using standard nippers, cut grey ceramic tiles into six or eight tesserae. These, when joined together, will form a running line. Allow some fluency with the width – too perfect a cut will give a mechanical result. Continue to use a grey tile also, to give a little shading at the thigh and armpit of the raised arm. Extend the grey colour into the cloak using tiles cut into four tesserae and,

as in the original, add a little blue colour in one area.

Cut dark terracotta tiles for the hair infill, nipples, mouth, folds of the cloak and cloak clasp, plus parts of the scabbard. Just a little use of this rich, warm colour adds interest, as in the original, where similar detailing was also accentuated.

Use white ceramic tiles to outline within all the black line drawing of the body, carefully articulating the tesserae when abutting the grey 'muscle lines'. Tesserae, because they can be cut to shape unlike the more unforgiving whole pebbles, can give special definition to the building-up of the figurative form.

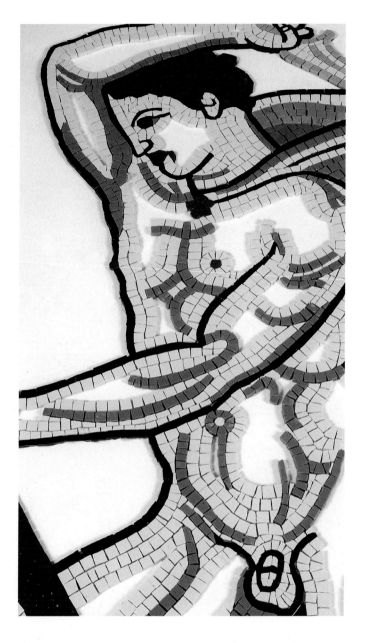

ABOVE: **Introduce black tesserae for the background.**

LEFT: **Detail of the upper part of the body and face showing the progressive anatomical build-up.**

It should not be just a filling-in, but a *defining* build-up. Each limb, the torso and the facial features should all be given attentive modulation. In this particular translation of the form, the emphasis is on strength of line and accentuation of any angular muscle tone.

The cloak adds movement to the whole work, as well as providing a pleasing energetic force behind the figure to give greater emphasis to the striking action. The rest of the figure and the cloak will be made of the white ceramic tesserae only – cut mainly into four.

Stand back from the work from time to time to gauge the direction of the tesserae – there will be many choices of direction. It is a question of looking and understanding in which direction the tesserae best help to modulate the form. Leave any areas that you are uncertain about, building up the form along the 'lines of certainty' first. All will gradually become apparent.

Hellenic work was frequently characterized by a dark or black background. The original inspirational pebble design was no exception, so the background of this new work will use black tesserae to both hold and offset the vigorously depicted figure. Choose a background *opera* to best complement the figure; *opus musivum* is one which extends a strong *andamento* or movement right to the edge of the work; that is, the background is built up by rows of tesserae following all parts of the image continually, to the very edge of the mosaic.

The figures in the mosaic at Pella stand on a multicoloured pebble ground, consisting of an accumulation of all the colours of the pebbles used in the work. I have introduced a ground of small pebbles – which were collected in Greece – to make a pertinent connection with the prototype. Even working on this small piece of pebble mosaic gives an indication of the complex technical skill required to make close tessellation.

Continue working with the black ceramic tiles up to the edge of the backing board. There is no frame in this work; no border. This emphasizes the fact that it is a fragment, or part of a larger work. The whole work is then to be grouted.

Grouting

ABOVE LEFT, ABOVE & BELOW: **Stages of grouting.**

Grouting both strengthens a work, making it more durable, and also brings it all together, resulting in the traditional characteristic finish, which gives equal weight to the tesserae and its gaps. Grouting works best when a work is relatively flat and is in need of this specific bonding.

In this mosaic, with its large segregated areas of white and black tesserae, a neutral grey Portland cement seemed an ideal choice.

Materials

- proprietary ready-mixed grey grout containing Portland cement
- containers or bowls
- latex or rubber gloves
- trowel
- soft cloths
- brick/mortar cleaner
- plastic or ceramic container
- brush
- large damp towel
- water

Put a quantity of the grout mix in a container – for this size of work, about two cupfuls. Add water to the proprietary grout mix, cautiously – if the mortar becomes too runny, add a little more grout mix, to form a mortar of drier consistency.

Wearing protective gloves, rub the mix into the whole surface of the mosaic, taking a little more care around the pebble region. Press carefully into all the interstices. With the soft cloths – I personally like traditional white dishcloths – wipe off the excess mortar. Clean the surface with more cloths, and leave to cure under a damp towel – the chemical hardening process, or curing, can take up to three days, benefiting from a long, damp situation. Remove the towel and carry the mosaic to a place where it can be washed safely with the mortar cleaner; this is a proprietary cleaner specifically made for removing cement, as it contains hydrochloric acid (HCl).

Wearing protective gloves, put some mortar cleaner in a ceramic or plastic container, and brush all over the mosaic. The cement scum will lift very quickly and easily. On completion, wash the surface thoroughly with water, or hose it down with a gentle spray. Allow the water to drain off the work, then dry it, lying it flat to prevent any warping of the backing timber.

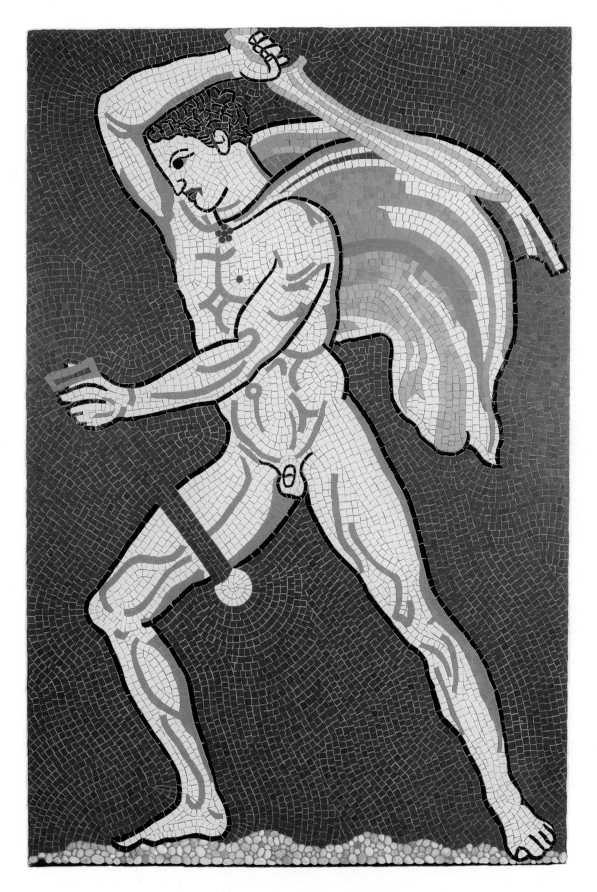

The finished work – THE LION-HUNTER.

The Finished Work

It is both extraordinary and humbling that a work from well over two millennia ago can inspire us today and teach us so much about the human form. This singular new work is dynamic and energetic, both in pose and bodily articulation – yet it is made up of few lines and little colour. It epitomizes for me a mosaic credo. Think simple, think direct and think strong, in order to achieve the truest results.

Postscript

The Hellenic use of multicoloured pebbles for decorating floors on a black ground in an illusionistic and polychrome manner was inverted when the concept was translated into an original and populist ground covering in Roman Italy. In southern Italy, particularly in Rome and the port of Ostia Antica, there emerged a flourishing period of mosaic flooring, from c.20BCE right up to the third century CE. This period is known as the black and white

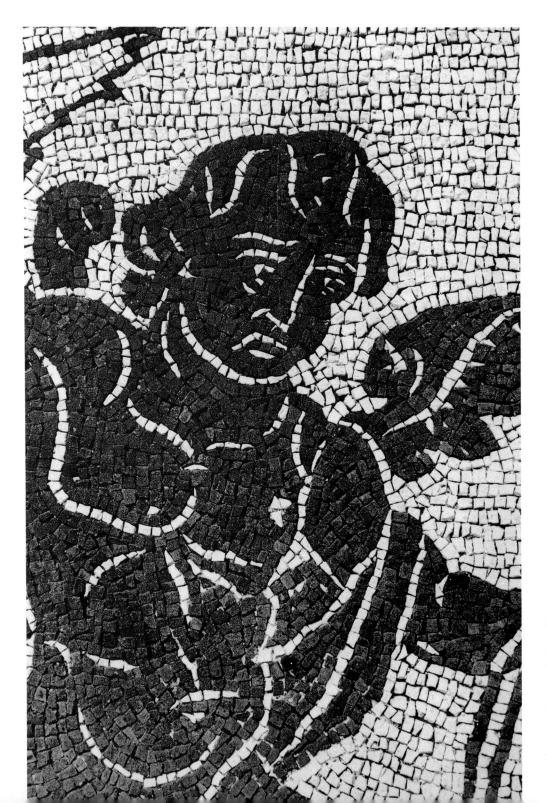

HEAD AND TORSO OF AN AMORINO/CUPID, **early third century CE, from the Terme di Caracalla/Baths (Museo Nazionale Romana di Palazzo Massimo), Rome, Italy. Photo: Elaine M. Goodwin**

era of mosaic making. It was extremely popular. The backgrounds were mainly of white tesserae, with landscape, decoration and figures silhouetted in black against them. Limestone and marble were used for the white tesserae and black volcanic stone (*selce*) for the black tesserae. These materials were relatively cheap, so vast areas were able to be covered.

The many figures depicted were from both mythology and life; they were often nude or semi-clad. The tesserae used were characteristically large, with an emphasis on simple linear internal modulation of the joints and muscles. The cement mortar was always clearly visible. However, even in this simple monochrome technique, elaborate and sophisticated examples proliferate, as in the figure torsion and modelling in the mosaics of the *Terme*, or Baths, of Caracalla, where internal white lines depicting the anatomy are of equal refinement to the earlier Hellenic examples at Pella.

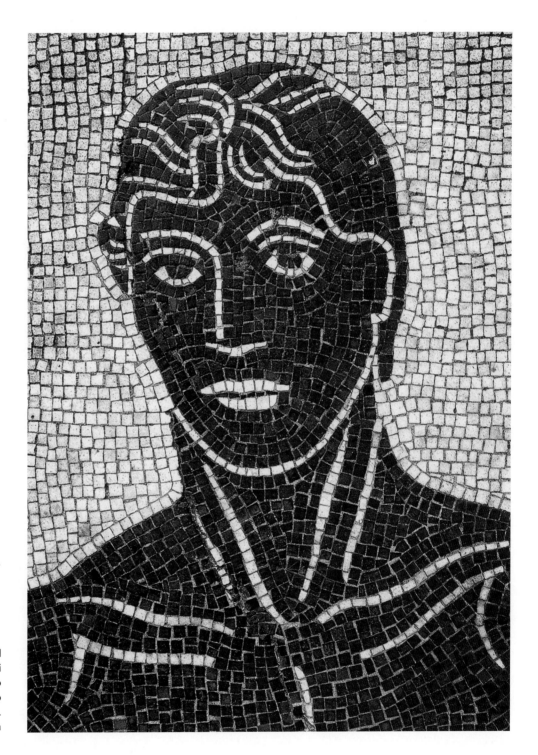

HEAD OF A YOUTH, early third century CE, from the Terme di Caracalla/Baths (Museo Nazionale Romana di Palazzo Massimo), Rome, Italy. Photo: Elaine M. Goodwin

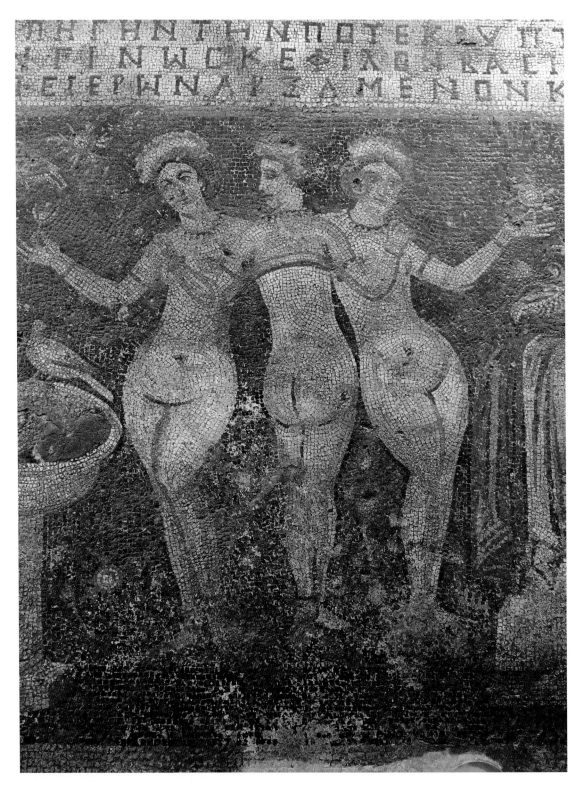

THE THREE GRACES, 4th century CE, **Narlikuyu village museum, Silifke (Seleucia), Turkey.**
Photo: Elaine M. Goodwin

PROJECT TWO –
THE THREE GRACES I

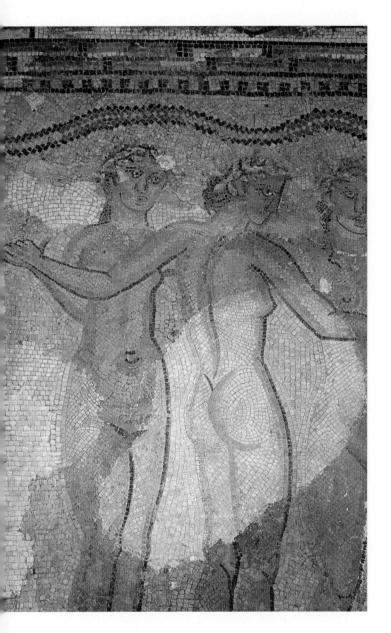

THE THREE GRACES, **detail, 3rd/4th century** CE, **Tetouan Archaeological Museum, Morocco.**
Photo: Elaine M. Goodwin

History

The Three Graces are prototypes of grace, beauty and artistic inspiration. Daughters of Zeus, King of the Gods, and three different mothers, their names are Thalia (Bloom), Euphrosyne (Joy) and Aglaia (Brilliance). The image of the interlaced trio comes

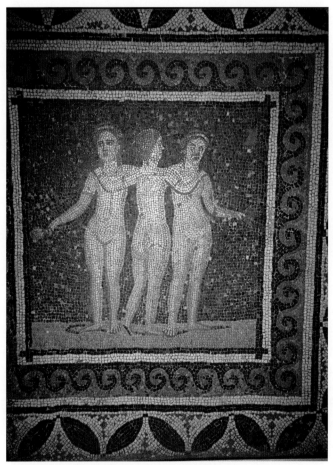

THE THREE GRACES, *emblema*, **Archaeology & Prehistory Institute, Barcelona, Spain.**

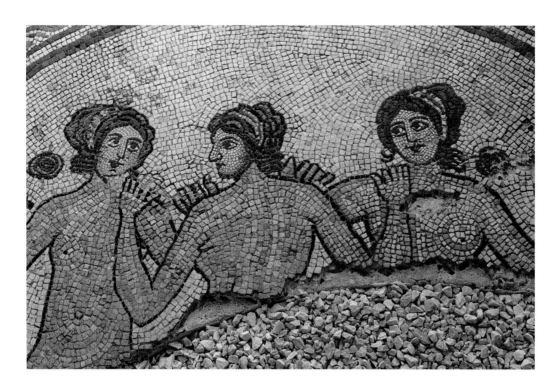

THE THREE GRACES, detail,
2nd/3rd century CE,
Archaeology Museum,
Egnazia, Puglia, Italy.
Photo: Elaine M. Goodwin

down to us from Ancient Greek art. It may well have developed from Greek Hellenistic mural painting, but although its origins are obscure, this memorable pose has intrigued and inspired many artists, painters and sculptors from antiquity through to the Renaissance, notably in the works of Botticelli and Raphael, and beyond to the painter Rubens and the sculptor Canova.

The grouped trio is usually portrayed unclad. In Roman mythology, the three female figures, regarded as personifications of beauty, were often portrayed as attendants of Venus and were a very popular image – Roman 'pin-ups'! Generally, the central figure is shown with her back to the viewer, which allows the artist to give full rein to the lengthy modulation of the back and buttocks. The two females at each side permit wonderful artistic expression of the female form in frontal pose.

Ancient mosaics of this grouping can be found in local archaeological museums in countries as far afield as Turkey, Morocco, Spain and Italy. Each individual panel bears local characteristics in drawing and in materials used.

Inspiration

The inspiration for this project is *Le Tre Grazie/The Three Graces*, a Pompeiian or Herculaneian panel fragment (before 79CE). It is to be found in the Archaeological Museum, Naples, Italy.

This small mosaic panel of *The Three Graces* is one of a number of works of art or other artefacts in which three standing female

forms are linked together by their arms. It may be that the three interlaced figures were derived from images of dance, as it is the rhythm of the image that gives such delight. In each extant mosaic fragment, the proportions of the figures may vary, but in the Pompeiian mosaic the elongated torsos have been my inspiration.

Drawing

Materials

- 12mm ($^1/_2$in) marine plywood: suggested size 107 × 107cm (42 × 42in) (for works over 60cm (24in), it is always desirable to use exterior marine plywood rather than interior quality timber to give a more substantial backing board)
- 3B and 4B pencils
- ruler
- putty rubber or eraser
- pointed felt-tipped marker pens
- coloured ink and brush

In a grouped image such as this, the placing of the figures within the panel is all-important. By concentrating solely on the torsos, a square shape holds the forms perfectly. The square shape is given a wide border frame to draw attention to the fact that it was originally a 'framed' *emblema*, that is, a centralizing panel of

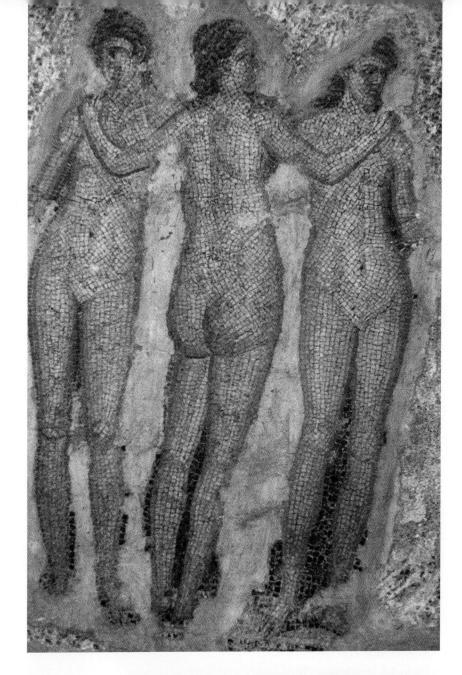

RIGHT: THE THREE GRACES.
Detail: Pompeiian fragment,
Archaeological Museum, Naples, Italy.
Photo: Elaine M. Goodwin

BELOW LEFT: **Detail: buttock area.**
Photo: Elaine M. Goodwin

BELOW RIGHT: **Detail: stomach area.**
Photo: Elaine M. Goodwin

A simple pencil line drawing, directly applied onto a marine plywood panel has been carefully outlined in felt-tipped pen.

a larger floor, and in essence, therefore, a picture within a frame.

It may help to colour the background within the figures, as in this work. I have also brushed, in gold ink, an area to simulate a frame and a ground base. Use a coloured ink of choice. The marble will not be grouted and the backing wood, if uncoloured, would otherwise show through.

Draw the figures directly onto the board. I find a centrally drawn line helps align the image. Draw loosely, by eye, or, if hesitant, square up a chosen design found on a postcard or in a picture book. Use a soft pencil (3B or 4B) to begin with. Emphasize carefully the parts that give most decorative satisfaction. The exaggerated elongation of the torsos in the original fragment from Pompeii intrigued me, as they appear so far removed from acknowledged classically admired female beauty; it is this aspect, and the relationship of one female to the other, that I have therefore concentrated on. When sure of your drawing, outline the image with a pointed felt-tipped pen.

Application

Materials

- variously-sized cubes of white or whitish marble (Carrara from Italy, or Afioni from Turkey)
- Venetian gold, yellow or gold-glazed tiles
- hammer and hardie
- long-handled mosaic nippers
- prodder/dental tool
- palette knife
- PVA adhesive/white glue and container
- small brush for brushing away marble debris
- pencils
- gold or other coloured ink
- brushes

Cut the cubes of marble in half on the hammer and hardie, or in square-shaped tesserae from a length of marble. This cut unit of material – a tessera – will form the basic unit of the work. Additional shapes can be cut further on the hammer and hardie, or with gentle care using simple long-handled mosaic nippers – Carrara marble is extremely soft and crystalline. Do not despair if the material seems to crumble; be gentle but firm with the cutting processes.

Begin work by outlining the forms with sensitive placing of the basic unit of marble, using a PVA adhesive to secure the marble cubes to the board. Contour within the drawn lines. Both marble and wood are porous, so adhesion is therefore excellent. Continue to work with close tessellation to create strong contour lines. Where the curve is acute, as in the contours of the area of the knee, cut smaller-shaped tesserae to modulate the shapes – this may be half a regular square shape. These areas of tighter tessellation will give visual interest to the whole design, especially so in this work, since all of the image will be in material of the same colour and type.

Select areas of the greatest interest first, for example the navel and buttocks, to abut the tesserae to the outer contour lines. In working with the figure, it is the gradual modulating with the tesserae that creates areas of anatomical rhythm. Allow the tesserae to create their own form. A dental prodder is an excellent tool to help position the tesserae in awkward corners.

Scrutinize carefully the area left for additional building up of the tesserae. A natural tessellation with the square-shaped pieces of marble that works visually is better than forcing anatomical exactness. Regard the whole area from time to time by standing back from the work. Taking an overview sometimes frees the movement of expression by giving fresh insight, which is not easily obtained when working at close quarters on the work.

Always affix the 'certainties' first; these are areas where you want to emphasize an anatomical element, for example the navel, the belly, or particular muscles. Leave any awkward areas and return to them later, when you can get an overall look at the whole form. This way of working will help dictate whether you emphasize length or movement, or merely 'fill in'. If the awkward remaining areas are done in one sitting, this will also give ample time for readjustments (and these may be many) while the adhesive is still sticky enough for repositioning.

Continue to use simple white cut cubes of marble to create the 'ground' on which the figures stand. Frame the mosaic with larger cubes of white marble, using the largest tesserae for the outer edge of the frame.

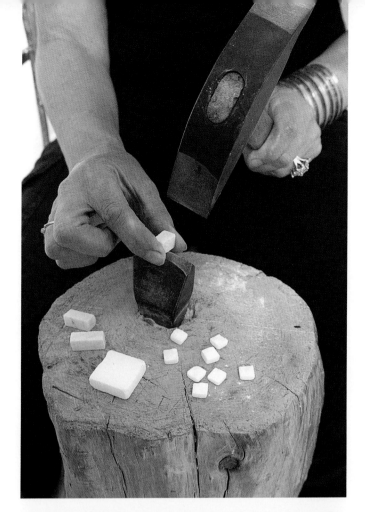

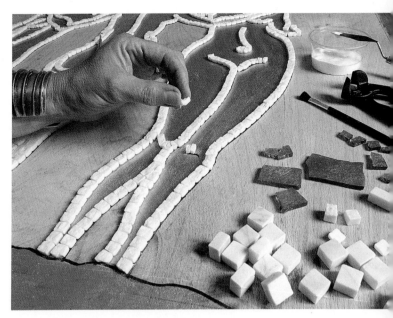

ABOVE: Outlining the figures in lines of white tesserae.

LEFT: Cutting marble on the hammer and hardie.

BELOW LEFT: Contouring an intricate area.

BELOW: Use a pencil as a guide line in building up the form.

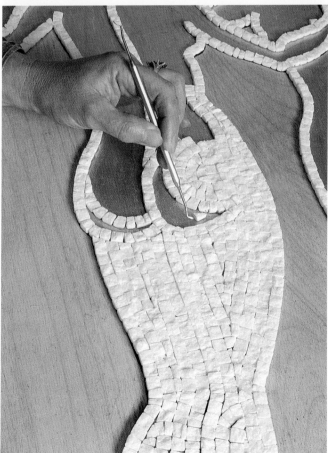

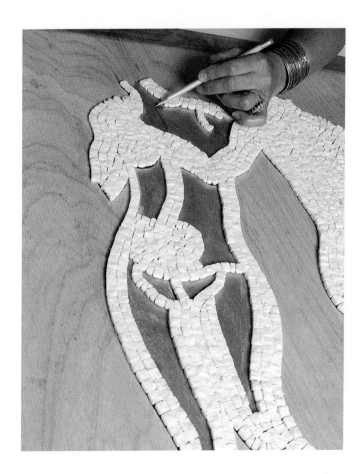

27

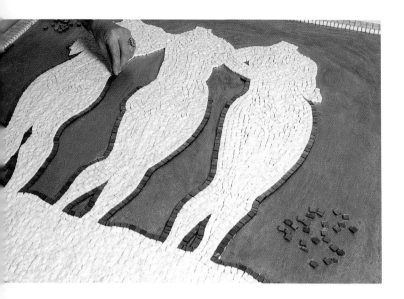

Begin to outline the background to the figures.

ANDAMENTO

This is a classical term meaning flow or movement (*andare* – Italian 'to go'; *andatare* – 'a path'), and refers to the serpentine tessellation that follows a curved form. In ancient mosaics it was employed *within the form* for fine articulation. In classical works, this type of 'worm-like' application was achieved by *opus vermiculatum* (*vermi* – Italian 'worms'), in which one or more rows of tesserae followed the outline of a subject in order to highlight it. Here, *andamento* is employed *externally* for accentuated background movement. The term is now loosely applied to all ways of laying tesserae in order to emphasize movement.

Grouting

Materials

- a proprietary ready-mixed grey grout
- bowls
- trowel
- latex or rubber gloves
- soft cloths
- damp towel
- water

Grout only the frame with a ready-mixed unpigmented grey grout. Wear protective gloves and add water carefully to a cupful of the mix in a bowl, until a fairly thick mortar is formed. Press this mix into the interstices. Wipe clean with a soft absorbent cloth and allow the grout to cure under a dampened towel for around three days. Wash carefully with clean water using a clean cloth. The grouted frame will provide a strong border for the rest of the design, which will remain ungrouted.

Paint the remaining backing board with the coloured ink. Again, I have used gold, but use a colour of choice. Use the Venetian gold or glazed tiles of gold or yellow to work up the background. (The original classical fragment can be seen to have had a dark blue background, as can be ascertained from a very few remaining tesserae.) In this case, I have chosen to follow the form, that is, by outlining the figure with one layer of tesserae before building up the background. This means the background to the image will be one of enhanced decorative rhythm and flow – *andamento*.

The Finished Work

The finished work is a simple, yet faithful homage to the ancient classical grouping. The use of marble for the figure links the material to the original classical mosaic, and the gold or gold-glazed tiles add a rich element in creating a new and memorable image.

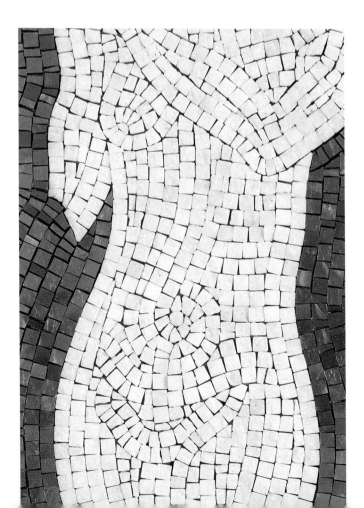

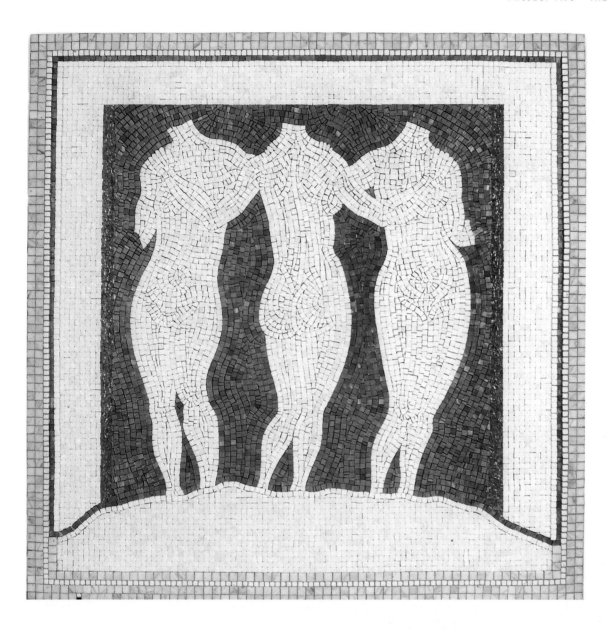

**The finished work
– THE THREE
GRACES I.**

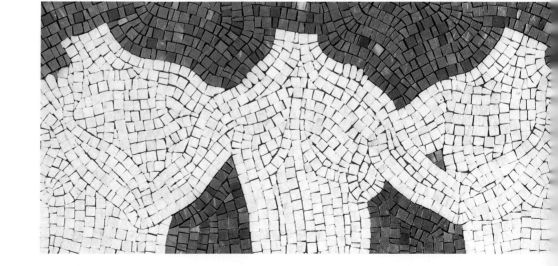

LEFT: **Detail: stomach area.**

RIGHT: **Detail: linked shoulders.**

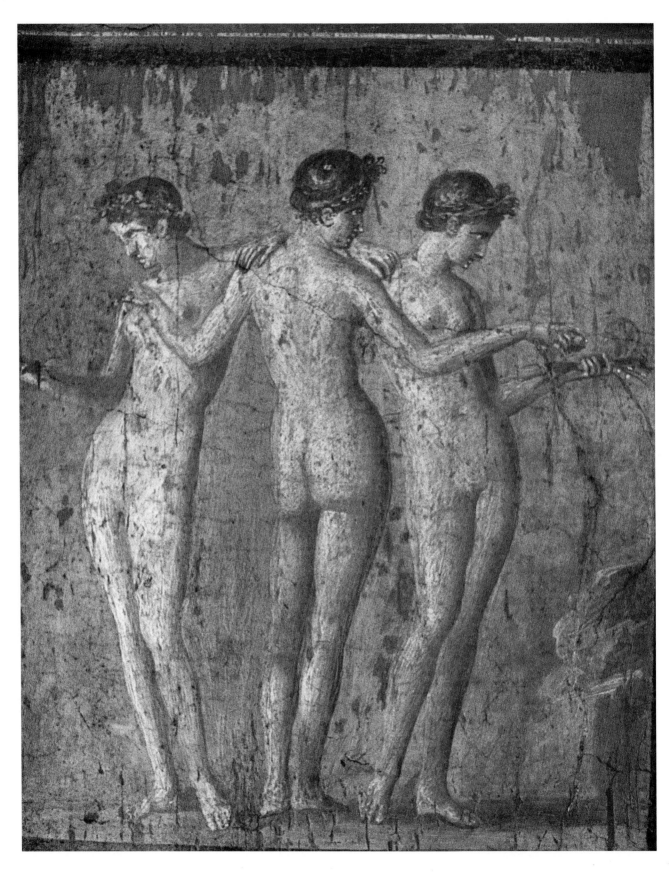

THE THREE GRACES, **wall painting (56 × 56cm (22 × 22in)), pre 79CE, Archaeological Museum, Naples, Italy.**
Photo: Elaine M. Goodwin

PROJECT THREE –
THE THREE GRACES II
(AN ALTERNATIVE DESIGN)

Inspiration

By gently elaborating the curves of the female forms, particularly in the pelvic area, a distinct lyricism can be created between the figures, as can be seen in two Pompeiian wall paintings of the first century CE and a headless sculpture from Ostia Antica, also of the same period.

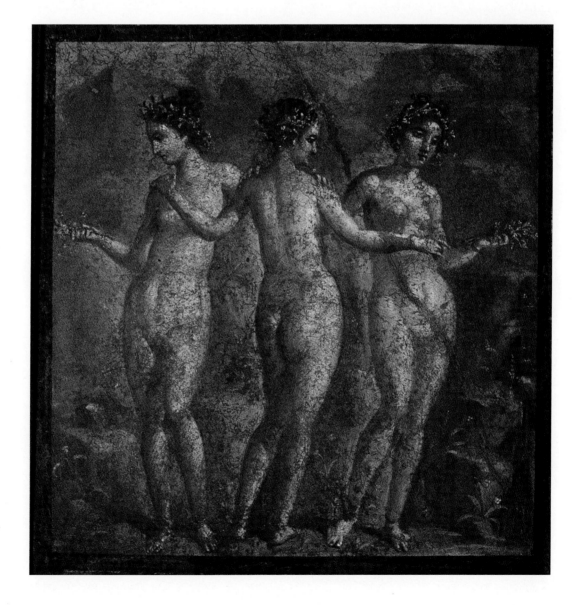

THE THREE GRACES
**pre 79CE wall painting
(56 × 56cm (22 × 22in)),
Archaeological Museum,
Naples, Italy.
Photo: Elaine M.
Goodwin**

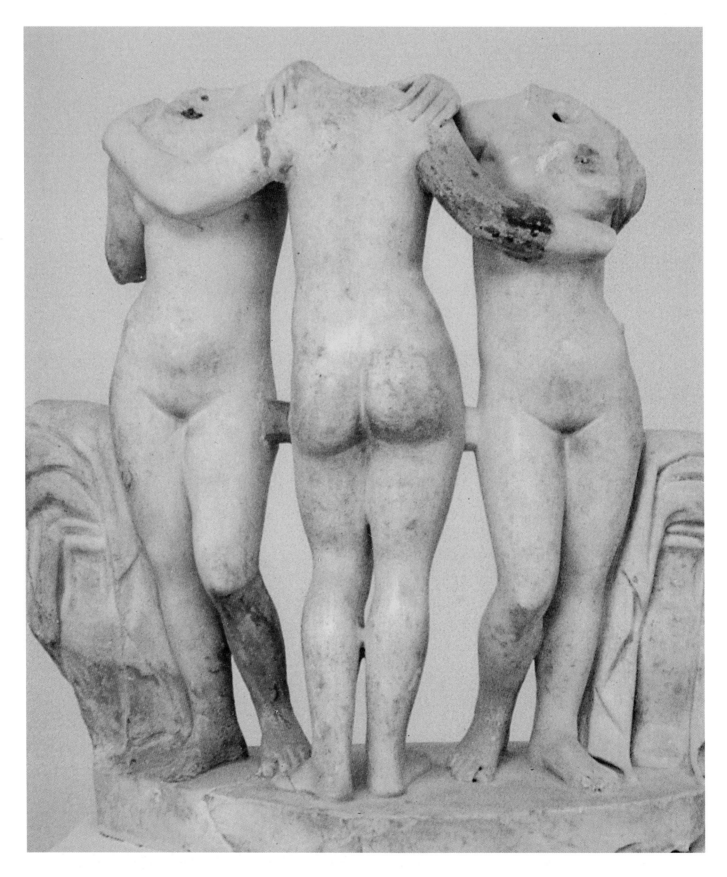

THE THREE GRACES, marble sculpture, 1st century CE, Archaeological Museum, Ostia Antica, Italy.
Photo: Elaine M. Goodwin

Draw smooth pencil contours onto a board, building up a continuous and strong outline.

Drawing

Materials

- 12 mm (¹/₂in) plywood; suggested size 46 × 46cm (18 × 18in)
- pencil
- ruler
- putty rubber or eraser
- felt-tipped pen
- silver or other coloured ink
- white ink
- brushes
- relief plaster copy of *The Three Graces* (copies can be purchased from bric-a-brac stores or junk shops)

In allowing the weight of the two end figures each to rest on one leg, the rhythmical quality of the ensemble can be further pronounced. This has the effect of tipping the pelvis and forcing the shoulder area to slope in the opposite direction. This opposing plane of positioning is called *contrapposto*, a subtle twist in the torso, which was much enjoyed during the classical period and used extensively in sculpture.

Use a brush and coloured ink – this time I have opted for silver – to paint the area within each figure. The figures will not be grouted, so any naturally forming gaps will show this colour, rather than the timber colour. Transfer the highlights to the drawing using white ink. These help to accentuate the curvaceous

HIGHLIGHTING

By shining a light at a particular angle on a simple plaster copy of *The Three Graces* (the original is in the Louvre in Paris), a variety of raised anatomical forms are highlighted. This simple aid exaggerates the areas to be accented, in this case with a different material but of the same colour.

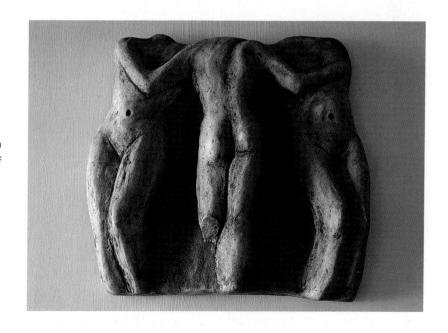

Raised anatomical highlights on a relief plaster copy of THE THREE GRACES.

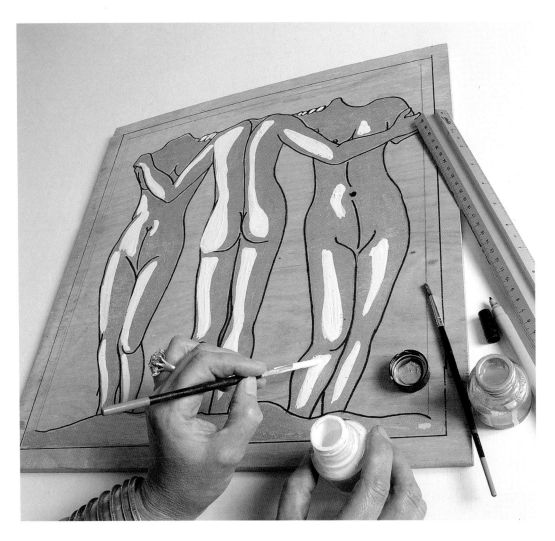

LEFT: **Painting the highlights.**

BELOW LEFT: **Working on the background.**

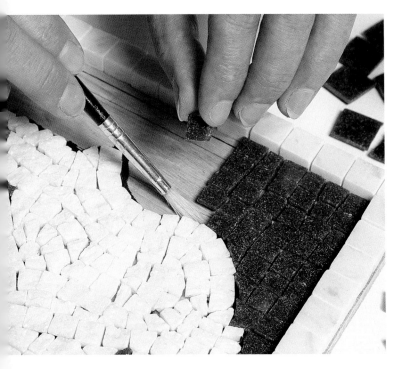

quality of the image and give an added appearance of a three-dimensional aspect. Strengthen the drawing further by outlining the image with a felt-tipped pen. This thicker line gives a visually stronger guideline when contouring the figures with tesserae.

Application

Materials

- Carrara marble cubes
- white vitreous glass
- white smalti
- blue vitreous glass
- hammer and hardie
- mosaic nippers
- PVA/white glue adhesive and container

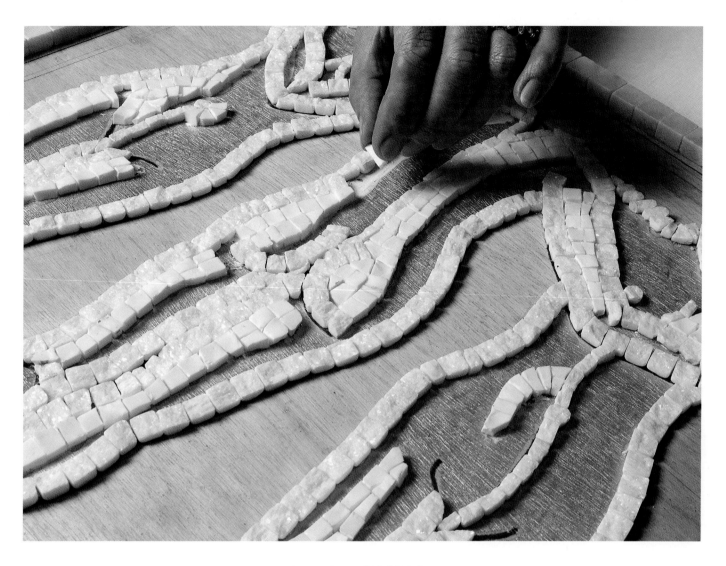

Contouring and highlighting.

Starting with the contours, build up the design as in *The Three Graces I*, using white marble tesserae. The highlights are depicted using white Venetian smalti or white vitreous glass: this change of material gives an added interest and a wondrously subtle three-dimensional effect.

Rather than the gold used in *The Three Graces I*, this time a blue background was added as in the Barcelona mosaic of *The Three Graces (see The Three Graces I)*. This will give a strong colour contrast to the forms. In this case, *opus tessellatum* was used – a way of laying a background that was much used in Roman mosaics. It is a simple background of fairly regular square-shaped tesserae set in a horizontal or vertical manner. Cut the tesserae that abut on the figure with care, setting the tesserae fairly close to the image.

Finally, add a simple retaining frame of uncut cubes of Carrara marble to surround the image.

Grouting

- proprietary ready-mixed grey powder grout
- latex or rubber gloves
- palette knife
- soft cloths
- damp towels
- containers
- small water jug
- masking tape (optional)

Only the background will be grouted, using a ready-mixed sand and cement powder grout. (You may wish to mask out the three images when applying the background grout, although with very careful application this fiddly job can be avoided!) Wearing plastic gloves, make a fairly stiff cement mortar by cautiously

adding the water. Work the grout carefully into the background area. Clean away the excess grout and leave the mortar to cure under damp towels for two to three days, then remove the cloths and clean with water and soft cloths.

The Finished Work

The completed work has strong classical overtones and a wondrous lyrical quality.

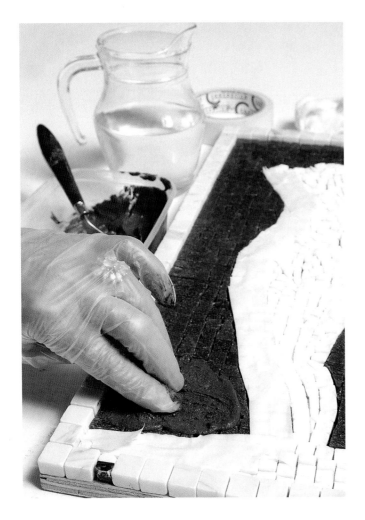

ABOVE: **Grouting the background.**

ABOVE & BELOW RIGHT: **Detail: stomach area.**

BELOW: **Detail: linked shoulders.**

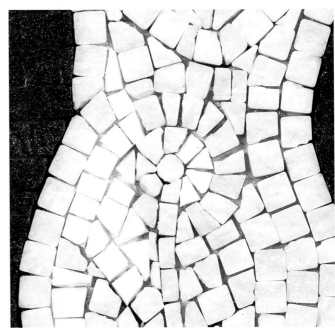

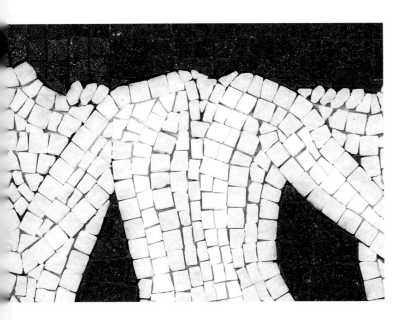

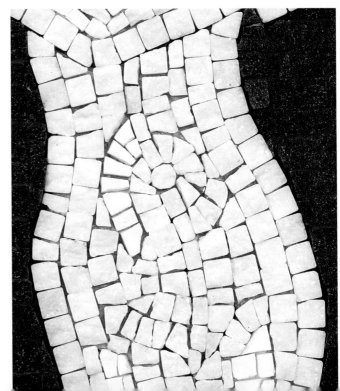

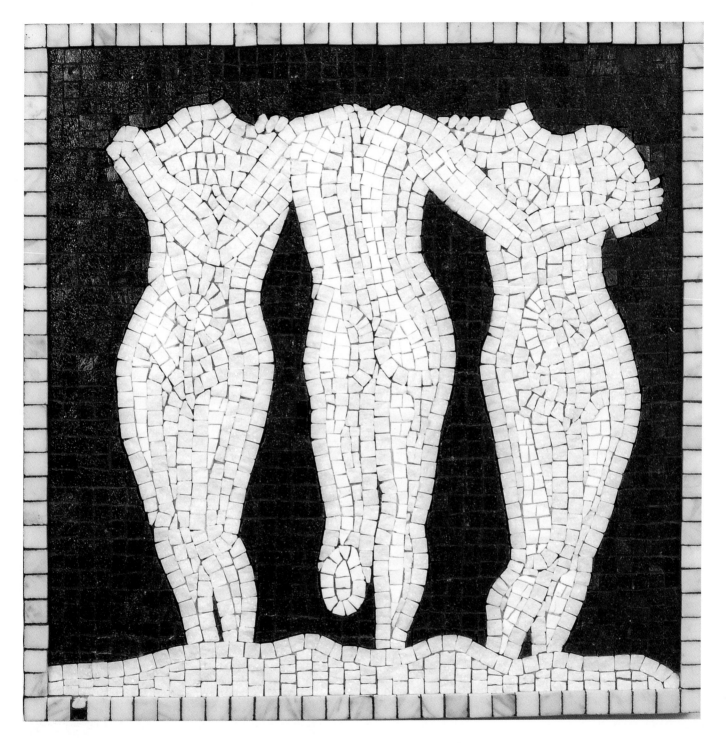

The finished work – THE THREE GRACES II.

THE RUDSTON VENUS, **fourth century** CE**, Kingston-upon-Hull Museum, England.**
Photo: Elaine M. Goodwin

PROJECT FOUR –
VENUS I

History

The Greeks had a passion for proportion, which the English art historian, Sir Kenneth Clark, referred to as a 'mystical religion'. The figure in art could be a visible form of this – a means to portray ideal geometry, encompassing rhythm and line. The female form of Venus, the Roman goddess identified with the Greek goddess Aphrodite, has intrigued numerous artists. She has appeared under a great many proportional guises, with various balancings of femaleness in her system of curves!

In the mosaic figurative pantheon, Venus was extremely popular in a variety of poses. She was portrayed all around the Roman maritime world as well as in inland provincial cities, thus allowing the female form to be admired in bath houses and villas alike. Ancient illustrations come down to us from the work of copyists. Popular themes, like the Venus form, were repeated from wall paintings and sculpture as well as mosaic.

Aphrodite/Venus has inspired, and been truly immortalized by, poets, writers and artists since Ancient Greek and Roman times. She is goddess of love and beauty, life and fertility. Wherever the Romans went around the Roman Mediterranean world with their Greek mosaic makers, images of Venus appeared in many forms. Although Venus assumed a number of formalized poses, from reclining and admiring herself in a mirror, to standing and applying a necklace, or arising from the sea, all were essentially visual celebrations of the female form. She most often appears nude or lightly draped and was intended to be looked upon with pleasure.

It is generally believed that notebooks and collections of sketches were widely distributed around the Mediterranean, each artist adding to – or detracting from – a previous image, in the same way that I am doing in this book, in which we will explore two very different images of Venus.

THE EROTIC

The nude form is a subject of art and all art is naturally concerned with sensory images. As part of human nature is to observe, touch and unite with another being, so to observe the unclothed form can contain the erotic – a sensual appraisal as well as a spiritual appreciation. The unclad form can also be made to make the viewer aware of other aesthetic emotions, for example ecstasy, humanity, energy, pathos and harmony. After all, the body is that most sensual of interesting objects – it still excites the senses today, as it most certainly did in ancient times.

AN AMATORY EMBRACE BETWEEN A YOUNG WOMAN AND A CROWNED EPHEBE (a young citizen who has recently attained manhood), fourth century CE, the Archaeological Museum, Piazza Armerina, Sicily, Italy. Photo: Elaine M. Goodwin

Inspiration

This image of Venus, almost fully emerged from the sea, is for me a delightfully captivating one. She has a full figure, ripe and beneficent, and offers a frontal pose, with arms raised to part her wet hair. The mosaic hints towards realism, with a juxtapositioning of tones and colours that accentuates the 'reality' of the female; yet she seems to be virginal and vulnerable – a truly touching mix of emotions. Thus she appears as both a symbol of sensual pleasure and of a divine yet earthly beauty.

VENUS ADORNED, **fourth century** CE, **El Djem (ancient Thysdrus), Sousse Museum, Tunisia. Photo: Elaine M. Goodwin**

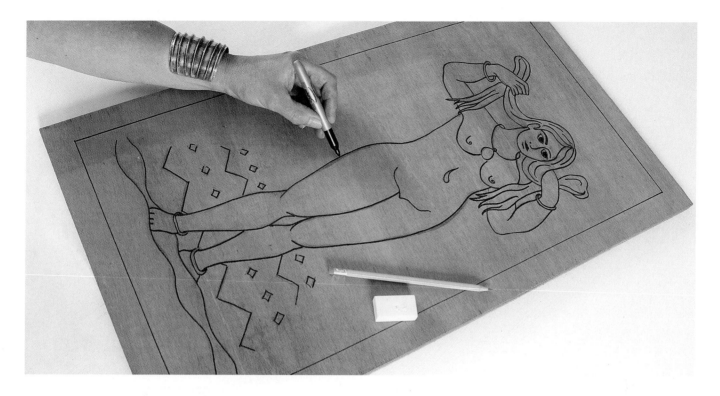

Drawing the image with a border and the sea indicated.

Drawing

Materials

- 12mm (¹/₂in) plywood panel, suggested size 70 × 40cm (28 × 16in)
- pencils
- ruler
- putty rubber or eraser
- marker pen

On this occasion, I have remained fairly true to the original image, just slightly elaborating her full figure to give an impression of abundance. To adhere closely to an original, if you are uncertain of your drawing prowess, you may need to take a photocopy of the work and enlarge it. This can then be transferred to a backing board using carbon paper or an equivalent to create an accurate image.

After drawing in pencil, strengthen the outline of the form with a marker pen – this helps to clarify the shape of the figure and makes it easier to work on. Do add some of Venus's attributes, for example her bracelets and necklace. Frame the work with a border line and add some slight references to the sea, such as zigzags and/or wavy lines. Keep this simple for greatest effect.

Application

Materials

- unglazed ceramic tiles (choose a rich palette of pink, yellow, terracotta, black and brown, ochre and white, to emulate the traditional local limestones and marbles)
- mosaic nippers
- PVA adhesive/white glue and container
- palette knife
- prodder/dental tool
- brushes

In this mosaic, I decided to replicate the leaning towards naturalism so gently hinted at in the original. To aid this, it is necessary to use a tonal representation. This means that the tesserae should be cut very small, so as to ease harmonious visual blending. Cut each tessera tile in half, then in half again and divide this also into four, each whole tile in fact yielding sixteen pieces. The work will be created throughout with this basic size of tesserae.

Look carefully at the original and outline the figure in a variety of tones. Although the basic drawing line is made with a square shape, from time to time you will need to cut even

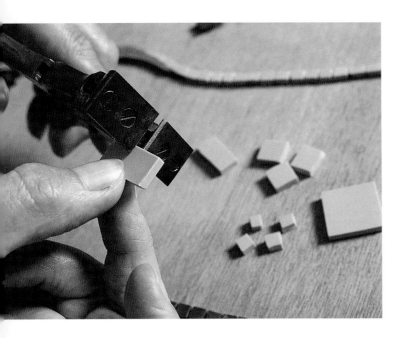

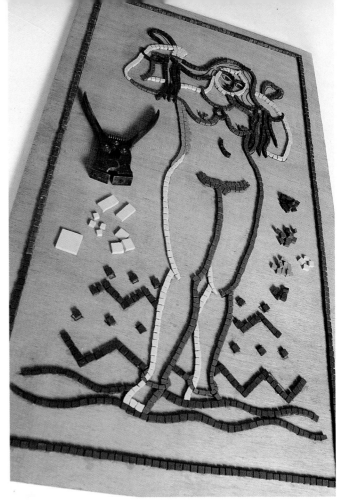

ABOVE: Cutting a tile into sixteen tesserae.

ABOVE RIGHT: Outlining the figure and the sea symbols.

BELOW RIGHT: Building up the top half of the figure.

BELOW: Working up the form.

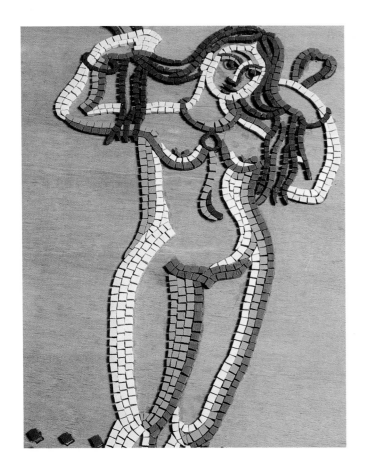

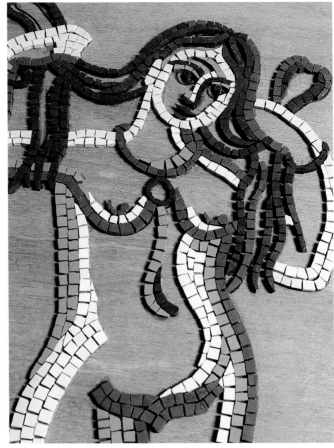

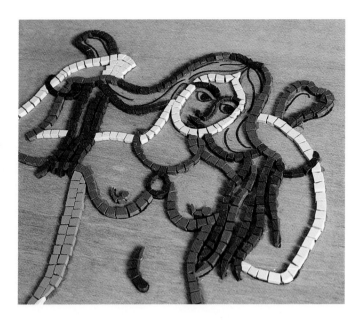

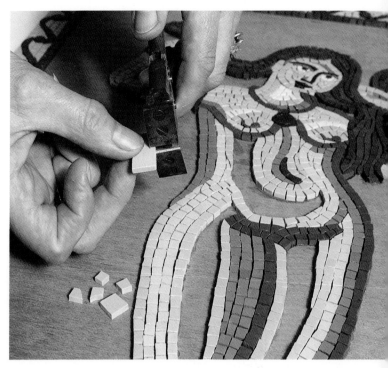

ABOVE: **Outlining the top half of the figure.**

ABOVE RIGHT: **Add lighter colours for accentuated tonal modulation.**

BELOW: **The border design, using cut circles as space markers.**

ochre will draw attention to any shading of the anatomical form. The yellow colour, being of an even hue to that of the pink, will merge and give a certain luminescence to parts of the form.

You will need to make decisions as to the movement of the tesserae and where to start and finish a colour. Mosaic is a very forgiving medium, in that its decorative aspect allows for a great variety of possibilities. If in doubt about the direction of the tesserae, leave that part of the work alone for a while and continue to build up the form in another area. You will be amazed

smaller shapes for good tessellation. Gradually you will learn to think in terms of a solid cube of material – the tessera – and not in terms of pencil or pen. As the Venetian artist, Lucio Orsoni, said, 'The only way to create a mosaic, which is untranslatable into any other art form, is to think mosaic when you are producing it.'

Begin to modulate the figure by working from the outline inwards using the dark ochres and yellow colours. The dark

CUTTING CIRCULAR TESSERAE

To cut a small circle, cut a tessera in half, then half again. Cut off the four corners, then proceed to nibble the edges with the mosaic cutter to form a circle, as shown below.

Diagrams showing the cutting procedure for creating small circles.

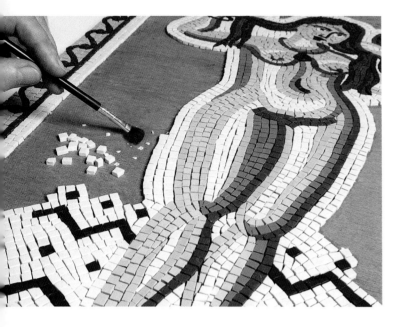

Outlining the form and border with rows of white tesserae; a brush is useful to clear any dust debris that always occurs when cutting tesserae.

of the border design will give moments of relief from close scrutiny of the figure. Measure out the border into fairly even parts. In this design, small circular tesserae act as initial space markers, before adding a linear wave pattern.

Continue to add the softer, lighter hues to the figure. In some areas, such as the belly, create pleasing curving shapes, to help articulate the form.

Finally, use white tesserae for the remaining body areas. These bright highlights will complete the tonal exploration of the figure and give the feeling of a soft, more naturalistic form.

Use white tesserae of the same small size to form a background. Outline the figure and also the inner border, with two rows of white tesserae. This latter will help to stabilize the image within its white background and stop 'floating', that is, the form appearing to be too detached from its border, as can sometimes happen in a small framed work.

how, with careful scrutiny and frequent long overviews, your understanding of mosaic figurative form-building will increase at each working sitting.

When greater moments of indecision occur, begin work on the border design. Choose a geometric pattern for this, symbolic of the sea, for example a wave crest. The repetitive nature

Grouting

Materials

- ▓ proprietary ready-mixed grout
- ▓ bowls
- ▓ trowel
- ▓ latex or rubber gloves
- ▓ soft cloths
- ▓ damp towel
- ▓ water

Grout the whole mosaic with a simple ready-mixed grey grout. Wear protective gloves and put a quantity of the grout in a bowl – about a large cupful. Add the water carefully, and mix with the trowel until the mortar is uniform and fairly stiff. Press into all the interstices, wiping carefully clean with damp cloths. If any pieces become dislodged – for example, sometimes the tiny pieces are rubbed off during the grouting process, replace them and regrout at the end of the grouting process.

Leave the mosaic to cure under a damp towel for up to three days, then wash with clean water and leave to dry flat naturally.

The Finished Work

The little Venus has emerged as a gently beneficent form, an image of natural female beauty, re-evaluated in a ceramic mosaic medium. A Venus of this kind would be an ideal goddess to introduce into a bathroom setting.

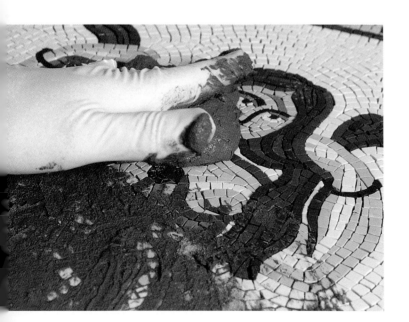

Grouting the mosaic.

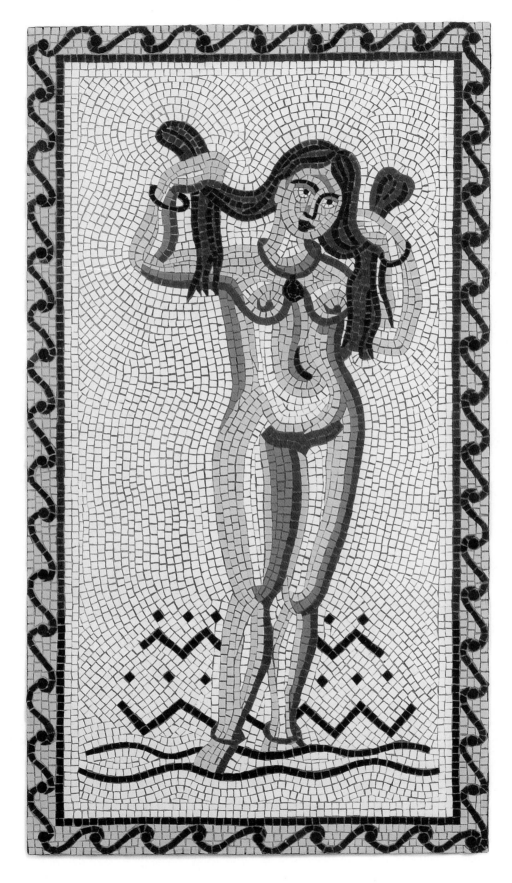

The finished work – VENUS I.

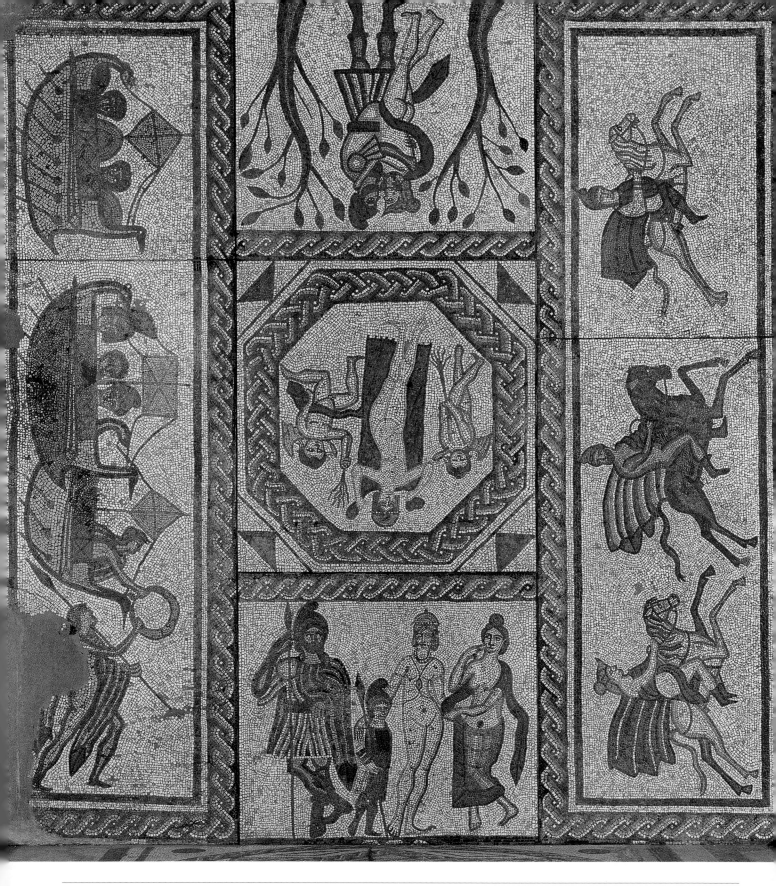

* This is a five-panel mosaic, relating the story of Dido and Aeneas by Virgil. *Left panel:* Aeneas and his men set sail, blown by a storm to Carthage. *Lower-mid panel:* The figures are of Aeneas, Cupid (son), Venus (mother) and Dido, Queen of Carthage. *Right panel:* Venus conspires to bring about a passion between Dido and Aeneas whilst riding in a hunting party led by Cupid. *Top-mid panel:* Dido and Aeneas consummate their love – their passion symbolized by swaying trees. *Central panel:* The narrative consequence of the love affair enforced by Venus: the upwards-positioned torch held by Cupid signifies Aeneas's departure to found Imperial Rome; the downwards-positioned torch, held again by Cupid, signifies the abandonment of Dido and her subsequent suicide.

PROJECT FIVE –
VENUS II
(AN ALTERNATIVE DESIGN)

History

This iconic figure of Venus in a central panel in a late Romano-British floor is part of a unique mosaic, in that it tells a complete story. The narrative form is rare in mosaic and in this case it is from the *Aeneid* by Virgil, the Ancient Greek writer (70–19BCE), who recounts a beautiful yet tragic tale of doomed love, that is, the story of Dido and Aeneas.*

Venus, mother of Aeneas and the goddess of love – the emotion pivotal to the tale – is the central motif. She is a figure that has entranced me for years and I often pay a visit to view her, as she is in a museum only thirty minutes from my studio.

The floor from which the mosaic was lifted showed the feet of Venus aligned towards the three steps of a cold bath area, the *frigidarium*, or plunge pool. This would have been a wonderfully appropriate position from which to view her unclothed form and also to enjoy a cultural tale when coming out of the bath and drying.

Inspiration

Late Roman mosaic workshops, or *officinae*, in this case at Lindinis (Ilchester), often employed local workmen who were perhaps less accomplished than the practised itinerant Greco-Roman mosaic workers, or *musivarii*. It is, however, the simple, elegant naïveté of the goddess, pale against her dark mantle, which here captivates the viewer. The strong silhouetted form is riveting, memorable in its octagonal frame. Venus is accompanied on either side by two simply drawn winged figures of her son,

Cupid. On one side, he is triumphantly kneeling on one leg, carrying a flaming torch held high, symbolic of Aeneas's destiny as the acknowledged founder of Imperial Rome, and on the other side he dejectedly holds a torch downwards, a poignant reminder of Dido's destiny, one of anguished lost love and a suicidal end.

In elaborating the drawing of the goddess, I have also adapted the pose from another striking Venus image, that of a painting by

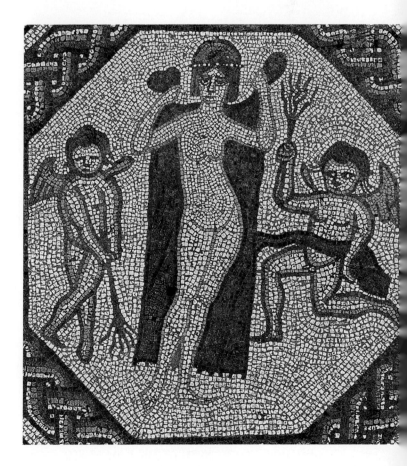

'VENUS WITH TWO CUPIDS', central emblema from
THE LOW HAM MOSAIC.
Photo: courtesy of Somerset County Museum

'Scenes from THE AENEID', THE LOW HAM MOSAIC, *c.*340CE,
Somerset County Museum, Taunton, Somerset, England.
Photo: courtesy of Somerset County Museum

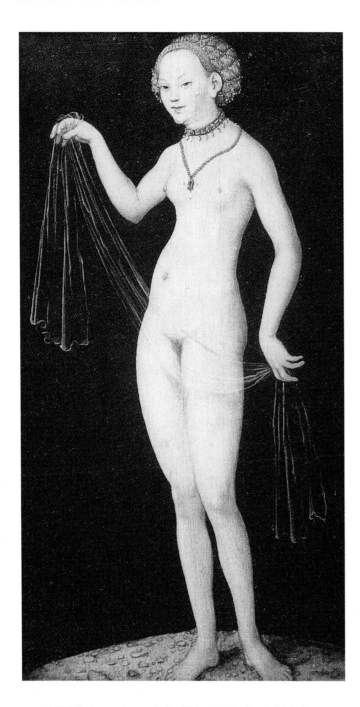

VENUS, **Lucas Cranach the Elder, 1532, the Städelsches Kunstinstitut, Frankfurt, Germany. Photo: Elaine M. Goodwin**

Drawing

Materials

- 12mm (¹/₂in) exterior marine plywood, suggested size 100 × 122cm (40 × 48in) (for works over 60cm/24in, it is advisable to use exterior marine plywood rather than interior quality timber to give a more substantial backing board)
- pencil
- putty rubber or eraser
- marker pen
- ruler
- large T-square ruler
- water-based emulsion paint
- brush

The figure has little internal modelling and consists mainly of one, whitish colour. The board is primed with white paint before beginning the drawing, to be touched up from time to time as it becomes marked in the making. If the work is to be left ungrouted, the background will therefore show through as white rather than the warm timber colour.

Indecision – such as whether to grout or not to grout – should be accepted when beginning a new work. Each new mosaic's outcome is not predestined, as if it were a painting by numbers. It should evolve at each sitting and be a very naturally occurring creative process. At this stage, the possibility of grouting can be considered and preparation made for both considerations.

For the drawing, I have borrowed from both the Roman mosaic Venus and the painting of Venus, while adding unique elements, specifically in the important shaping of the mantle or drying towel. The symbolic torches of the original mosaic are realigned

Drawing and touching up the base with white paint on a panel where the figure and border are indicated.

the German artist Lucas Cranach the Elder (1472–1553). In this painting, a sinuously elegant form with very little internal modelling, Cranach creates a memorable image in a similar mode. Both figures have slender waistlines, swelling stomachs, narrow shoulders and long tapering legs. In both works, the sinewy, undulating female form is held against a dark background.

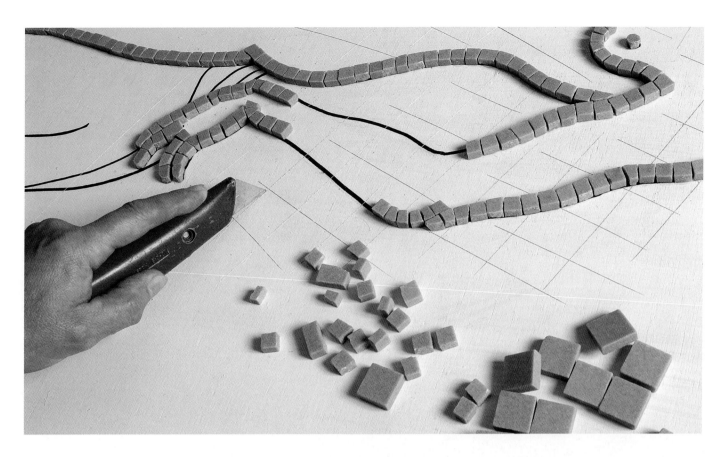

Score the board with the Stanley blade and begin to outline the figure (the scoring aids adhesion of the tiles to the painted backing board).

within the mantle and are also echoed in the positioning of the hands – one up and one down. Whatever art image is to be your inspiration, never fear to make it your own in this way. All art is a palimpsest of plagiarism! However, always create with real under-standing of *what exactly* is inspiring you and *what exactly* you are adding – or leaving out. The strength of your conviction will give strength to the artwork.

Outline the finished drawing, made up of strong, sinuous lines, with a marker pen. I intend to make up some sort of bor-der, but have indicated this with only its width at this stage.

Application

Materials

- unglazed ceramic mosaic floor tiles of earth colours: terracotta, white or natural, black, dark and pale blue, ochre and grey
- Carrara marble cubes
- hammer and hardie
- long-handled mosaic nippers, both regular and heavy duty for the most stubborn thicker floor tiles
- prodder/dental tool
- palette knives
- PVA adhesive/white glue and container
- Stanley knife/craft blade

Grouting (if applied)

- proprietary ready-made grout powder
- containers
- protective gloves
- trowel
- soft cloths
- damp towel
- brushes
- water

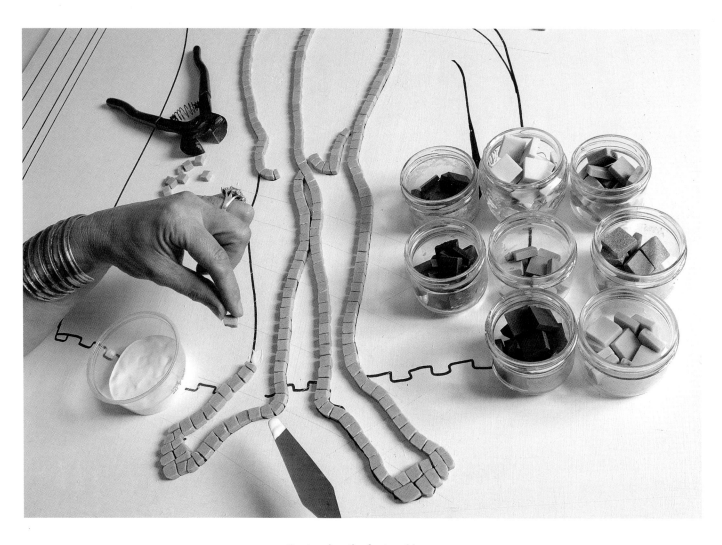

Contouring the feet and legs.

The Romans used a limited palette of colours, dominated by the colours of local stones. The colours of *The Low Ham Mosaic* include:

▨ whites – chalks, limestone
▨ reds – brick tiles, red sandstone and cut Samian ware (a glazed clay)
▨ blacks and greys – burnt bricks, shale and tiles
▨ blues – Purbeck marble, shale and limestone

To begin, with the craft blade, score the painted board with short strokes to aid adhesion.

It will be obvious that this late Romano-British mosaic was created in situ, as the tesserae are of regular size throughout the work. In particular, note the size of the pieces used in the head and hands; they are equivalent in size to those used in the rest of the mosaic. This lends a certain naïveté to the image,

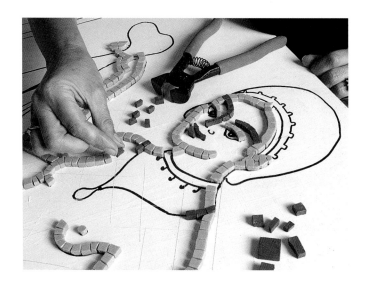

Working on the face and necklace.

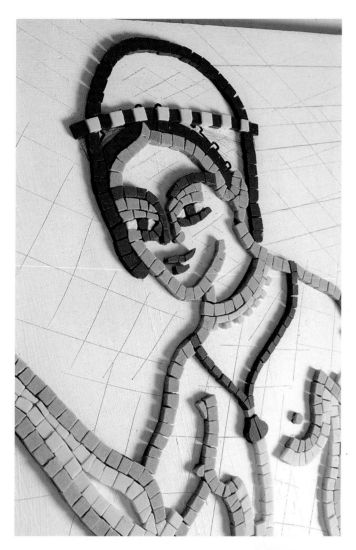

Building up the face and hair.

which can thankfully be kept in mind when cutting the chunkier floor tiles.

Cut regular squared pieces – one tile cut into four – to outline the contours of the figure. Use the grey tiles as in the Roman work. Work within the pen-marked line. Enjoy laying the tesserae along the linear sweeps of the figure. Articulate the toes of the feet and the fingers of the hands in the simplest of shapes – a resemblance to hand and foot is all that is required.

Outline the face of Venus, continuing to use the grey tesserae, but introduce terracotta tiles to depict simply the nose and mouth. The terracotta colour will help to define the face of Venus when viewed from a distance. Continue to use the terra-cotta colour deep into the chest area, by adding a common attribute of the goddess – the necklace – in a pleasing shape. Articulate the features of the face, the lips, eyebrows and nose, in tesserae of one colour. Use the ochre colour to add shade details and the grey colour to act as fill-in.

I have changed my drawing of Venus's headwear, her tiara, to that more reminiscent of the Roman mosaic. Do not be afraid at any stage to adapt your initial drawing; it is a guideline only.

Outline the mantle and figure (where it occurs against the mantle) in a row of black tesserae. Define the symbolic torches in an ochre colour.

Now all the detailing is complete, the inner modulation of the figure begins, using simple regularly cut tesserae. Begin to fill in the arms, starting within the contours, with the natural white-coloured tesserae. Give dominance to some contours over others for the clearest and simplest anatomical articulation.

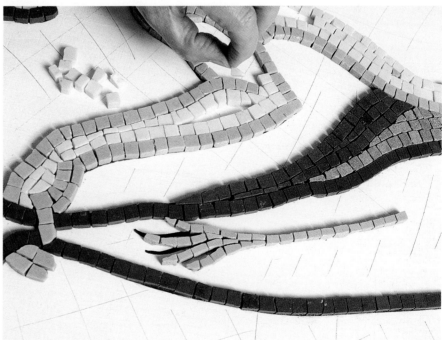

Begin to modulate the form within the contour lines.

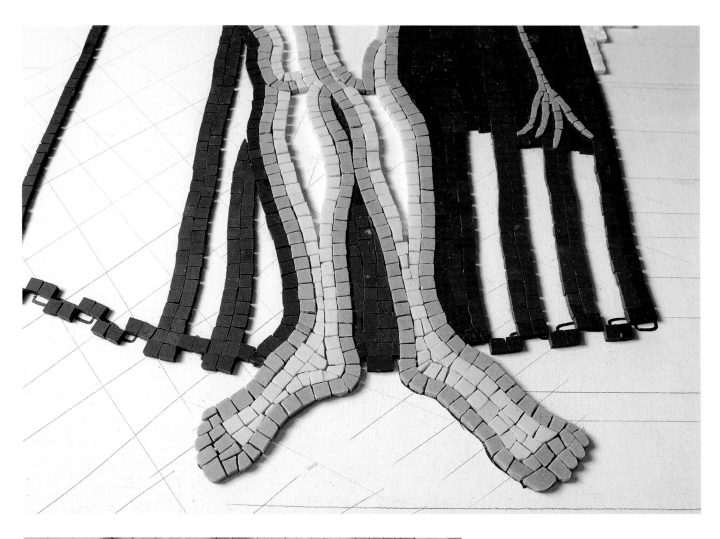

Building up the mantle, starting with pairs of tesserae.

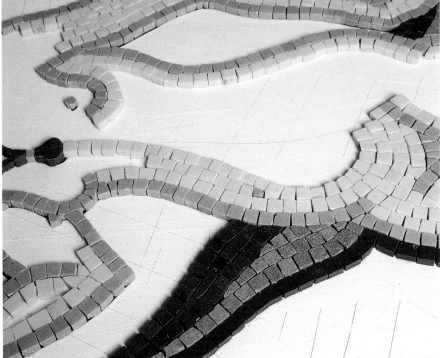

Building up the torso.

Background, showing the parallel placing of the tesserae.

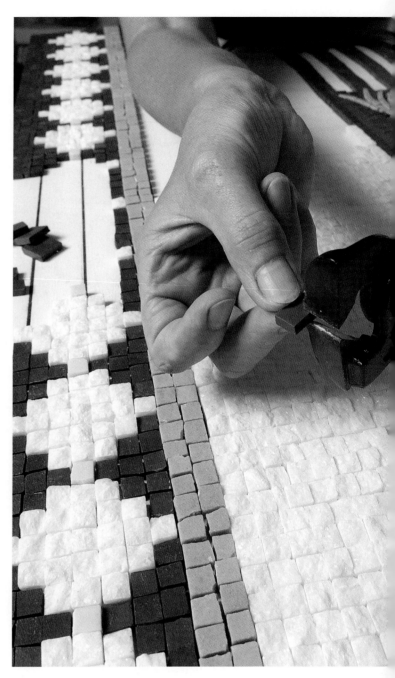

Working on the border.

Start also to fill in the mantle using squares of black tesserae. The indented hemline gives a strong defining structure to the one-coloured area.

Continue to fill in the feet, ankles and legs with the natural, white-coloured tesserae.

In articulating the torso, give prominence to the swelling belly area and how it curves at the groin. I have added a single tessera of terracotta to indicate the pudendum, as in the original.

It is a common feature of Roman mosaics to outline an image in one or two lines of tesserae before building up the background. I have chosen to outline the figure with two rows of marble tesserae, before laying a simple horizontal background, known as *opus tessellatum*. Some parallel lines drawn in pencil on the backing board will help to keep level the tesserae used for the background.

The border is an important feature in Roman mosaics, helping both to relate the mosaic to the room in which it is situated and to articulate the different areas within the mosaic. Borders were either complex and intertwining, or simple and geometrically elegant. I wanted to devise a simple form that could be repeated, both to complement the image and to give a strong framing element. Enjoy creating a border frame for yourself, based on the square-shaped tesserae.

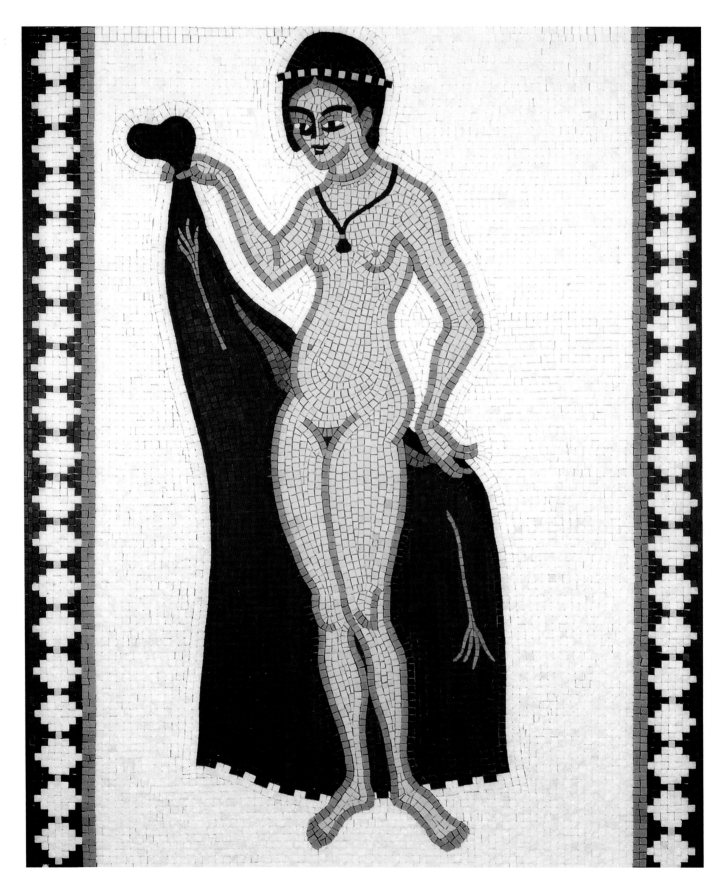

The finished work – VENUS II

The Finished Work

This new addition to the Venus pantheon upholds the transition of the slender, undulating female form which was explored with memorable naïveté by the ancient provincial mosaicists of the South West of England, and which was re-evaluated inimitably by the painter Lucas Cranach the Elder in his Venus paintings of the sixteenth century. This form of femaleness appeals to our contemporary idealism; that of a narrow-shouldered, slim-waisted, long-legged, tapering form – so unclassical and yet so elegantly satisfying.

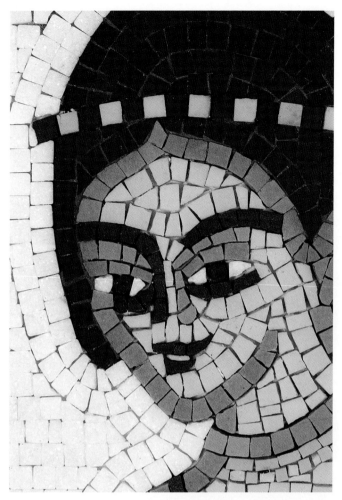

ABOVE: **Detail: the face.**

LEFT: **Detail: the stomach area.**

BELOW: **Detail: the right shoulder and arm.**

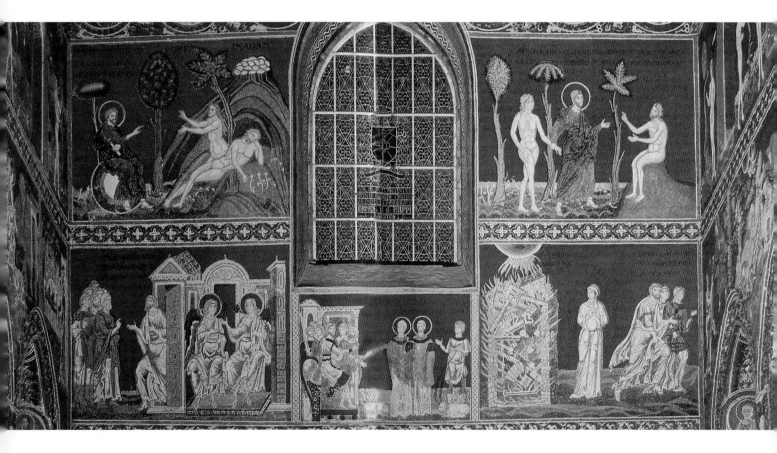

Detail from the interior mosaics of the Cathedral of Monreale, twelfth century CE, Sicily, Italy.
Photo: Elaine M. Goodwin

PROJECT SIX –
THE FIRST MAN

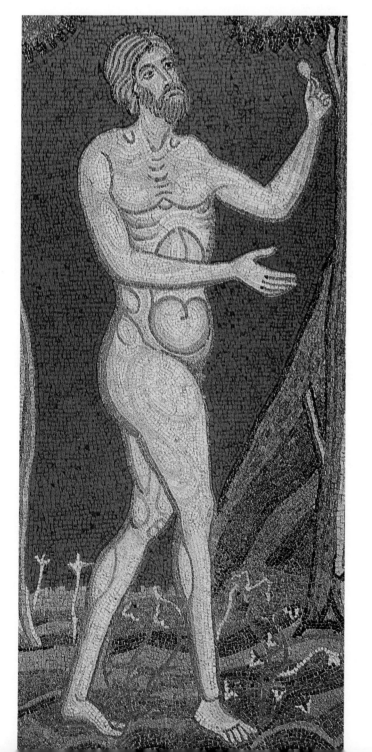

History

The vast mosaic schemes of the Cathedral of Monreale and the Palatine Chapel of Palermo in Sicily depict the history of the biblical world, from its creation leading to a world message. Both stupendous designs were constructed in the reign of the conquering Norman kings, Roger II and William II. They are believed to be the work of a dedicated group of mosaic artisans under an overall supervisor – a *pictor imaginarius*. There is a superb overlying congruity to the schemes and there would have been a form of iconographic manual, setting down pictorial formulae for each motif.* Altogether, the mosaics are a wonderful testimony to a fusion of Byzantine and Sicilian culture at an acknowledged height of artistic refinement – the twelfth century, or the so-called Middle Byzantine period.

Inspiration

The mosaics in the interiors of these two religious buildings are breathtaking. They were produced to stylistic and iconographic conventions. Each figure in Byzantine art is a single part of an overall design, not an individual in its own right, but in return, each creates a special relationship with the whole. However, as can be seen in the creation themes, where Adam is a pivotal player, this still allowed some leeway with regard to the expressive elements of the figures portrayed, which maintains a lively variant on what may sometimes be thought of as seemingly stilted forms.

In the creation story, after making the world, the Creator then makes man – the first man – and allows him full freedom in the

* From 787CE, at the Seventh Ecumenical Council, it was laid down that art was subordinate to theoretical and liturgical concepts and that artwork must adhere to a format – which, in effect, was a divine plan for universal salvation.

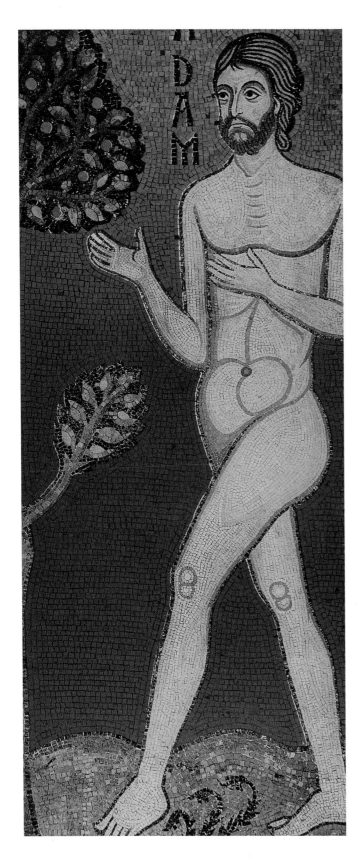

ADAM IN THE GARDEN OF EDEN, Palatine Chapel, Palermo, Sicily, Italy, c.1150.
Photo: Elaine M. Goodwin

newly made paradise. What intrigues me continuously when viewing this mosaic is the clever way that all of our attention is drawn to the figures and their gesturing, which in themselves elucidate the tale. No illusion is needed in these mosaics and little setting, as they are set architecturally in a hierarchy. The great expanses of golden walls allow the strong outlines of the shape to be stressed and permit a concentrated gaze on the figure forms – wonderful!

The features of the face of Adam are simplified, but not without some individual expression, a sort of an abstract verism, a non-physical truth. The body muscles are indicated, not, however, by a graded tonal modulation, but by stylistic angularity and strong *andamento*, or tesserae movement.

The superb decorative trees owe their inclusion in the original to a Saracenic tradition. Floral designs in mosaics of this period were an Islamic contribution, echoing the influence of Islamic Syria. These styles of design can be further enjoyed in the mosaics of the tenth century *mihrab* of Cordoba, in Spain.

Drawing

Materials

- 12mm (½in) plywood panel, suggested size 30 × 102cm (12 × 40in)
- soft pencils
- putty rubber or eraser
- felt-tipped marker pen

Using the two mosaics of Adam as inspiration, I have created a 'first man' in a three-quarter standing frontal pose, to emphasize innocence. By working on a narrow panel size, I wanted to

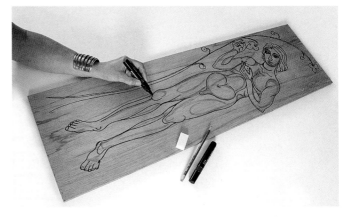

Drawing the figure on a narrow panel of wood.

explain the workings of a Byzantine mind in a restricted space, studying the application of the tessera in detail.

Draw with pencil first, before strengthening the outline with a felt-tipped marker pen, exaggerating any anatomical features, such as the knee and leg muscles, arms, collar bones and specifically the chest, stomach and groin area. Lend these features stylistic qualities. Pay particular attention to the expressionistic features of the hands and the tilt of the head – like the Byzantine masters, these will convey the message you require. In this case, as Adam holds the fruit which signifies his downfall, by slightly bowing the head, I aimed to convey both curiosity and vulnerability.

It is interesting in figurative representations of the Byzantine tradition of this period that full frontal representations were used for the principal sacred manifestations, such as images of the Pantocrator and the Madonna. The three-quarter view was kept for the secondary figures, for example Adam and Eve; with its ambivalent characterization, this position allowed for some degree of interpretation. Representations of evil, such as devils and Judas Iscariot, were shown in profile.

Application

Materials

▦ Venetian glass smalti in flesh colours, reds and black
▦ Venetian metallic gold leaf and red-gold leaf
▦ wheeled hand nippers
▦ small trowel or prodder/dental tool
▦ palette knife
▦ white glue/PVA and container
▦ black powder pigment
▦ containers
▦ pencil

As can be frequently observed in Byzantine mosaics, the outline of the figure often consists of a deep red or purple glass.

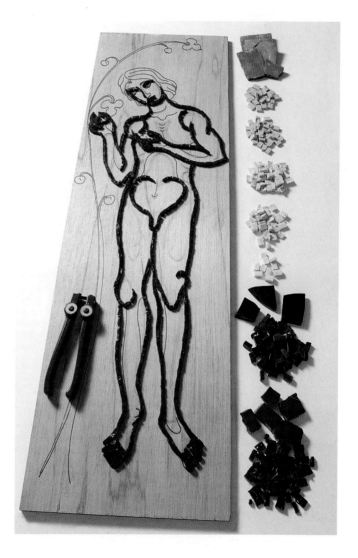

Cutting smalti.

Outline the figure.

Building up the tree and fruit.

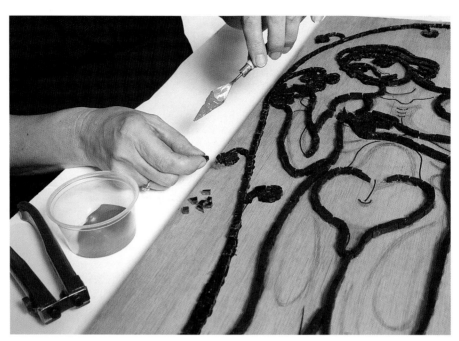

Begin to fill in the form with the lightest flesh tints first.

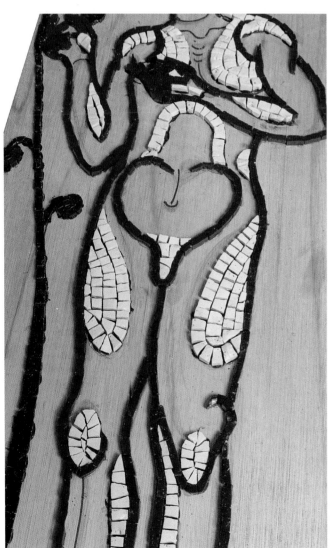

The wheeled nippers, which I find cut smalti well, are held in the cutting hand at a tilted angle. Introduce the smalto, which is generally of rectangular size, longitudinally into the 'jaw' of the nipper. Cut the smalto in half lengthwise and use the narrow rectangular shapes as a drawing or running line to outline the form. In this style of nipper, a bag can be fixed to catch the cleanly cut glass tesserae. Cut an amount of tesserae before beginning to outline the figure. In this way, the greater choice of pieces allows for a more precise definition of the form.

Begin to outline and fill in the decorative tree, adding its small fruits. The 'forbidden fruit' should attract the eye. For this, I have therefore used a brighter, more reflecting red-gold.

To stick the glass smalti, use a PVA adhesive, adding a dark pigment. I have used a permanent black powder, as this both colours the glue and slightly stiffens the setting adhesive so that the smalti can be pressed into the mixture. This setting adhesive recalls the Byzantine method of working – smalti were pressed into a setting mortar, which, historically, consisted of slaked lime, marble dust, albumen, or *pozzuolana*, a volcanic ash.

Traditionally, smalti are not grouted, since the grout can greatly lessen the surface lustre of the material when it becomes lodged in the imperfections and naturally occurring air holes of the glass. A thicker setting bed, by its nature, is forced to rise up between each placed tesserae, providing a stronger adhesion for the glass and leaving the surface clear and bright.

Begin filling in the figure by using the lightest flesh tones to 'fix' the stylized highlights of the figure. (This way of working will be seen to be very different from building up tonally, where the modulation begins with dark tones and ends with highlights.) Emphasize the ellipsoidal shapes of the muscles – a common

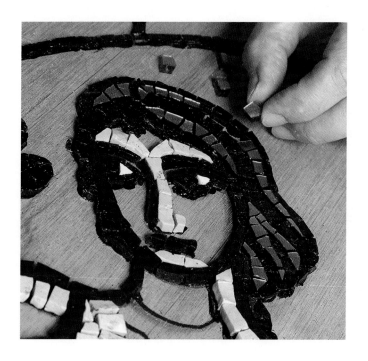

Adding gold for the hair.

feature of mediaeval art – in the arms and legs. In the face, add simple highlights to the nose and chin.

Use gold smalti to fill in the hair in a linear manner, light against dark, for example gold against black. Cut two small triangular shapes for the whites of the eyes – suddenly, even in this half-completed state, the figure takes on a 'life' of its own.

A Word on the Background

If the base of the work is flat, it is sometimes helpful to vary the setting bed slightly by introducing an undulating base to catch the light. Create an uneven surface by trowelling a cement or plaster layer onto the base in varying heights. Placing flatly created figures on an undulating metallic background will throw the emphasis onto the figures, which then become dark silhouettes in a glitteringly lit space. On the other hand, a flat, lustreless background can sometimes be a positive device in contrast with a lively figure surface. Should this be desirable, tessellate the gold firmly and closely; the figure, more loosely tessellated, will, by comparison, come 'alive'.

GOLD

A dominating characteristic of Sicilian mosaics and mid-Byzantine mosaics was the golden background, which often extended throughout the whole work. Where gold had been used in Roman work with sobriety, and served only to highlight details, in Sicily, with its influence from Byzantium, it was used extensively as a major contributing factor in the design. The vast expanses give a constantly flickering surface that never fails to enthral viewers. For me, this has led to an ever-absorbing personal enquiry into the engaging power of gold, and therefore light.

LUX REGNET II, **Elaine M. Goodwin, 2006, 36 × 36cm (14 × 14in).** *'Aut Lux hic nata est, aut capta hic libera regnet'* / **'Light was either born here, or captive, reigns here freely'** (as quoted on the mosaics in the Archiepiscopal Chapel in Ravenna, Italy).

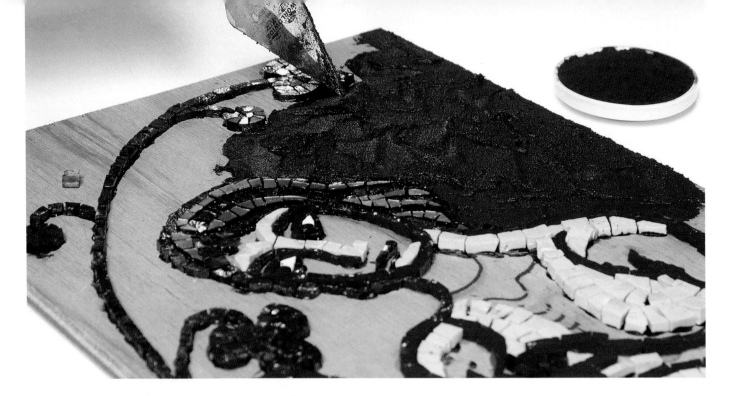

ABOVE: Creating a gently uneven background.

LEFT: Build up the form using a pencil to shade areas to be worked on and continue to fill in the background.

BELOW: Use small tesserae to articulate the facial features.

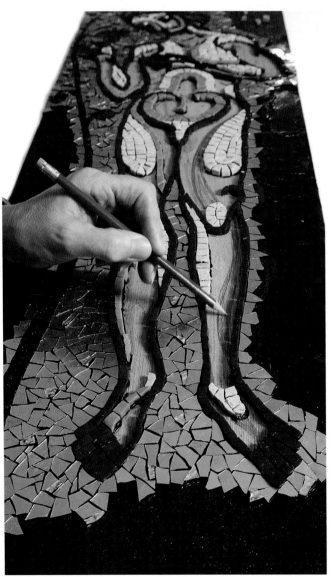

The choice of which method to use is yours, but however you set the gold, be aware of its great power to transform a work, and therefore its meaning.

I often begin a background while working on a figure. This gives time to reflect on the figurative modulation, while also helping to refine colour and texture complementaries for both figure and background. In this small panel, where the figure is composed of highly reflective smalti, I have decided to set the gold at gentle angles into a bed of fairly stiff cement; this provides a degree of tension and brings out the formal qualities of

all the materials to glitter and sparkle alike, thus creating a surface with a continual play of light.

Make a stiff adhesive paste by adding black pigment to the glue and, using a small pointed trowel, create a slightly undulating base on which to lay a golden background. Begin work on the background using *opus palladianum* – a crazy-paving type of tessellation. The figure is outlined first with smooth-surfaced gold tesserae, set at gently tilting angles. Granulated gold tesserae are introduced at intervals to give a variant and to add texture and increased light play.

When returning to fill in the figure, it may help to use a pencil to delineate the next area to mosaic with a darker flesh colour of mosaic smalti. As before, cut each smalto in half both longitudinally and also latitudinally to build up the required shape, giving a formal masculinity to the limbs and stomach area. Next, add darker tones to give shadow and form to the face.

The Finished Work

The richly textured mosaic of the figure of Adam, or the First Man, is given full expression in terms of intense colour and light. The power of the mosaic medium originally experienced when viewing the vast expanses of mosaic on the church walls in Sicily can begin to be fully understood even in such a spatially narrow panel.

The finished work – THE FIRST MAN.

PROJECT SEVEN –
ELAINE, SELF-PORTRAIT

The Art of Portraiture in Mosaic

In the final four projects, I have taken personal photographic images to demonstrate varying aspects of the art of portraiture in mosaic. The inspiration for each portrait, as in the previous projects, is directly linked to a memorable image from the mosaic pantheon, in this case a facial image. Each explores in intimate stylistic detail the differing characteristics inherent within each historical work.

The styles portrayed here incorporate: Pompeiian, with its Hellenic realist roots; Roman, with its simple but strong tessellation; Byzantine, with its jewel-like decorative approach; and early twentieth century, with its direct and freer expression.

History

The Romans were the first to develop a real tradition of portraiture. Images based on greatly revered works were handed down through succeeding generations as recorded and enjoyed artworks. There are few mosaics in this tradition, but those we have are a concrete reminder of the eternal fascination we have with our ancestry and place in history. These existing mosaics generally reflect a painterly tendency towards realism, yet with a sensitivity that has been successfully translated into mosaic.

Inspiration

In this tiny portrait of a wealthy noblewoman, with its leaning towards realism and individualism, what arrests me the most is

ABOVE: **An early photo of Elaine with the mosaic portrait, to illustrate the small size of the tesserae in the original in the Archaeological Museum, Naples, Italy. Photo: Elaine M. Goodwin**

RIGHT: PORTRAIT OF A POMPEIIAN WOMAN, **before 79**CE, *c.***40 × 30cm; Archaeological Museum, Naples, Italy.**

LEFT: RECLINING SELF PORTRAIT **(detail), Elaine M. Goodwin, 2007.**

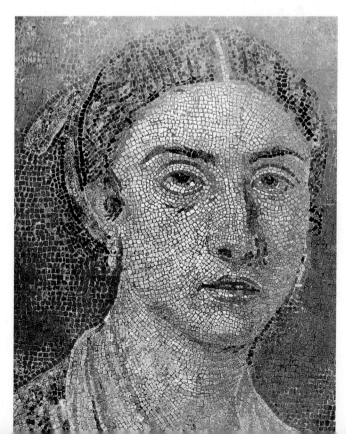

the gaze – how she looks at us while we observe her. This sense of a 'living moment' is what continues to intrigue me each time I return to Italy to view this portrait. The immediacy of the moment is enhanced by the treatment of the mouth. It is parted, with just the tips of the teeth on show, to give a sense of imminent speech – what the Baroque artists celebrated as a 'speaking likeness'. The lower lip, too, adds to this vivacity, with a line of occasional white tesserae giving a hint of moistness and therefore adding a sense of the 'now' in a 'just-wetted' lip.

Yet another remarkable feature is the small size of the tesserae, which contribute to the sense of naturalisism. The image was an *emblema*, a centrally placed mosaic that almost certainly owes its inspiration to Hellenistic painting.

ABOVE: **Photo, Elaine, 2007.**

BELOW: **Draw a simple likeness using a soft pencil.**

EMBLEMATA

From the early fourth-century BCE polychrome pebble mosaics at Pella, there was an emphasis by Greek mosaic artists towards a naturalism when depicting figures and objects, which can be identified as painterly realism. These works, though made with the simple pebble, were highly refined centrepieces that gave great weight to tonal modelling and expressive spatial understanding.

When in the third century BCE smaller centrally framed floor panels became part of Hellenic *villa* (country house) and *domus* (town house) decoration, small and sometimes tiny tesserae were cut from coloured stone and marble to create illusionally realistic artworks that were derivative of painting. These complex mosaics would have been created independently from the main floor, which would have been constructed in situ. These individual panels were called *emblemata*.

There is evidence to show that each *emblema* was made on a terracotta or marble slab tray in an *officina*, or mosaic workshop, then transported to a permanent site on completion. The viewing point was determined by the final architectural placing. *Emblemata* were commonly found in parts of domestic architecture with a static function, for example a *tablinium* (receiving room), a *cubiculum* (bedroom), the *oecus* (large reception room), an *ala* (small waiting area) and, most popular of all, the *triclinium* (dining room).

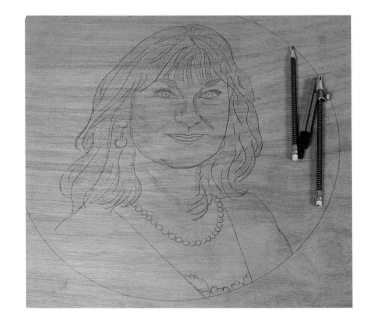

Drawing

Materials

- 12mm (¹/₂in) plywood, suggested size 51 × 48cm (20 × 19in)
- 2B/3B pencils
- compass and pencil
- putty rubber or eraser
- mirror

For an artist, the self-portrait is one of self identity and gives a particular insight into what it is to be human at a particular moment in time as perceived by the creator – in this case, me. It is a position of daunting exposure!

I began the portrait by drawing a circular medallion shape with a pencil. This was a popular format in the last years of Pompeii, so it seemed to be a fitting shape in which to create the portrait. Using a mirror, I did the initial drawing quickly, glancing at the looking-glass momentarily and drawing what I saw to create a spontaneous moment of reflection. In this way, any extraneous details were excluded, with just the essence of form and expression being caught.

Of all the portrait projects depicted here, this one will be the most painterly in effect, so the tesserae used in this work will be quite small, as in the original. The pre-Pompeiian portrait was probably influenced either directly or indirectly by a painting. The mosaic artist would be of Hellenic origin and his aim would be to give a naturalistic feel to the design – mosaic at that time, as in the Renaissance, was used as a medium to create pictures for eternity.

To aid the realistic approach, very small pieces of smalti will be used throughout. This material, with its vast colour range, will give good colour blending and a more painterly aspect should be achieved.

Application

Materials for Self-Portrait

- a palette of smalti in six to eight flesh tones, pink, brown, black, deep purple, terracotta, olive, grey, pearlized white, white, palest blue, pink-gold
- polished and unpolished black marble (*nero marquinia*)
- PVA adhesive/white glue and container
- black powder pigment and container
- hammer and hardie
- mosaic nippers
- palette knives
- dental tool/prodder
- tweezers

Materials for Grouting Circular Frame

- proprietary ready-mixed cement grout and container
- latex or rubber gloves
- small trowel
- black waterproof sealer
- soft cloths
- damp towel
- water

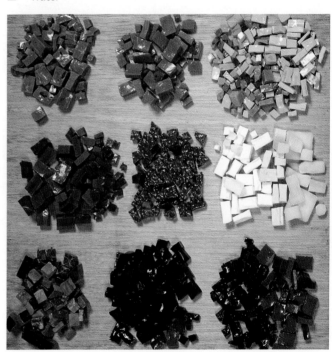

A selection of the materials used in this work.

1	2	3
4	5	6
7	8	9

Key to the palette of materials:
1. dark flesh-coloured smalti; 2. mid flesh-coloured smalti; 3. pale flesh-coloured smalti; 4. deep crimson smalti; 5. granulated pink Venetian gold; 6. white and pale blue smalti; 7. black marble (*nero marquinia*); 8. black, brown and terracotta smalti and smalti antico; 9. olive and grey smalti.

The palette is wide and various, with a mix of smalti and smalti antico – this latter is visually more granular and is excellent for areas of texture, such as eyebrows and hair, and as part of the facial make-up.

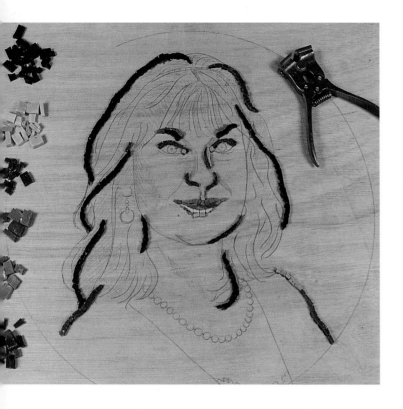

Select various parts of the image to begin the work.

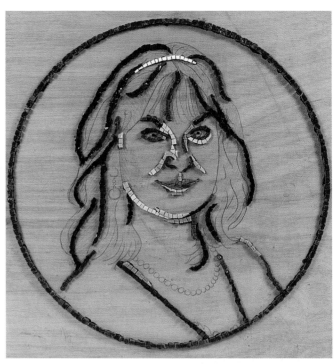

ABOVE, BELOW & RIGHT: **A series of photographs showing the progressive build-up of this more naturalistic technique.**

As in a painting, small areas have been selected from various parts of the face to begin with – imagine the initial brush strokes that begin a painting. Remember, however, the *only* blending will be done by the viewer's eye. There is no colour mixing or colour wash, or over-painting, as in a real painting; all is created with individual small cubes of saturated colour – a challenge indeed.

This way of making mosaic, in order to appear more naturalistic, uses a slow but rhythmic process. A momentum is built up by looking, cutting and laying, while continually running the eye over the whole picture plane – a very holistic approach. Small areas attract the eye, dictating the next tesserae placings – the eye, the laughter lines, the chin, chest and hair. Observe small nuances of shadow, colour change, highlight, texture and smoothness, and respond accordingly. All the tesserae are placed with an adhesive to which a little black powder pigment has been added. This extra thickness allows good adhesion to all parts of the uneven tesserae onto the backing board.

Cut small tesserae, using the natural imperfections inherent in the material of smalti to advantage – for example, a darker surface layer, a sandier mix, a more translucent finish. Never forget, you are creating a mosaic with painterly characteristics only; it is not a painting and should not deny the medium with too painterly a blend, or too closely placed tessellation.

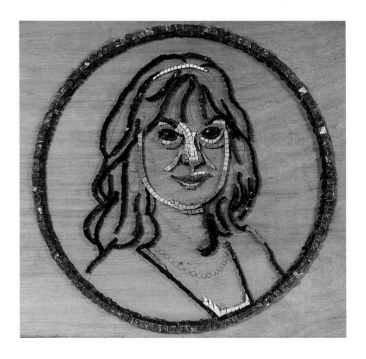

Slowly, tessera by tessera, the image is built up. To work in such a painterly way does not come easily to me. I have spent too many years working as a mosaicist, thinking and breathing the tesserae, accepting them as *individual* units of texture and

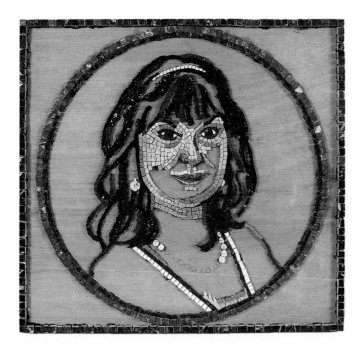

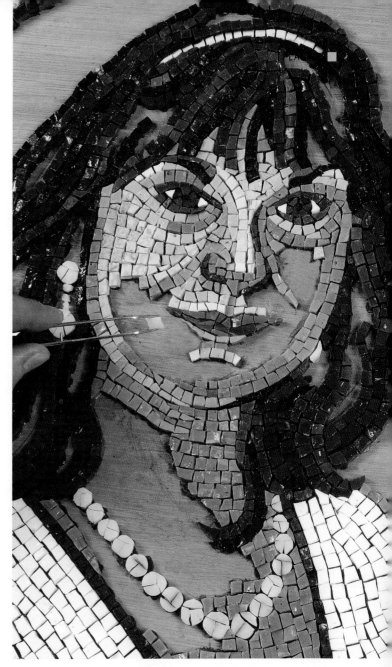

colour, important in themselves, never ever denying their individuality. To now merge and mute this characteristic is difficult, and in a self-portrait too, which by its very nature is already demanding – a searching enquiry, visual, theoretical and self-questioning.

From time to time in the making, I find it is good to turn to a practical issue, such as the mosaic edging. The inner round frame will be surrounded with black marble of a variegated kind. The dark colour will give the portrait a more supportive feel and will contrast with the lucidity created by the light-reflecting pale, flesh-toned glass of the face.

Although smalti, of which the portrait is made, are traditionally left ungrouted, the edging frame is of single polished black marble cubes. It is useful to grout this prior to infilling the area. Use a ready-mixed grout. Make up a small quantity with a little water to a thickish consistency and, wearing protective gloves, rub into the outer frame, which is made up of single tesserae. Wipe clean and keep damp for about three days. The exterior edges of this frame will be sealed with a black resinous sealer, which is waterproof. The type of sealer used in car maintenance is trustworthy and easy to apply, following the instructions supplied.

The garment is made up of simple cubes of white glass smalti, in contrast to the intricate shading of the face. The pearl necklace and earrings, specifically chosen to make a direct connection with the choice of the sitter in the original portrait, are created with pearlized glass, giving just enough interest on the flesh-coloured expanse of the neck and chest. The hair is made up of strands of rich and dark tesserae in terracotta, deep

Using long-handled tweezers to place a small tessera.

purple and crimsons, black, olives and the inevitable grey. It is important to note that the whites of the eyes are in fact smalti of the palest shade of blue – this avoids a stark and staring glare!

When working on a more complex area, as in the modulation of a cheek, nose or chin, the most prominent parts can be enlivened with a lighter, brighter tessera or two. Then the simple tweezer comes into its own – there is a wide variety of types, short- and long-handled, pointed and chisel-ended, and all have their uses. I find it invaluable to use the tweezers to pick up and place a tessera in one area without gluing, in order to assess its impact and regard its position by slight turns and tilting before

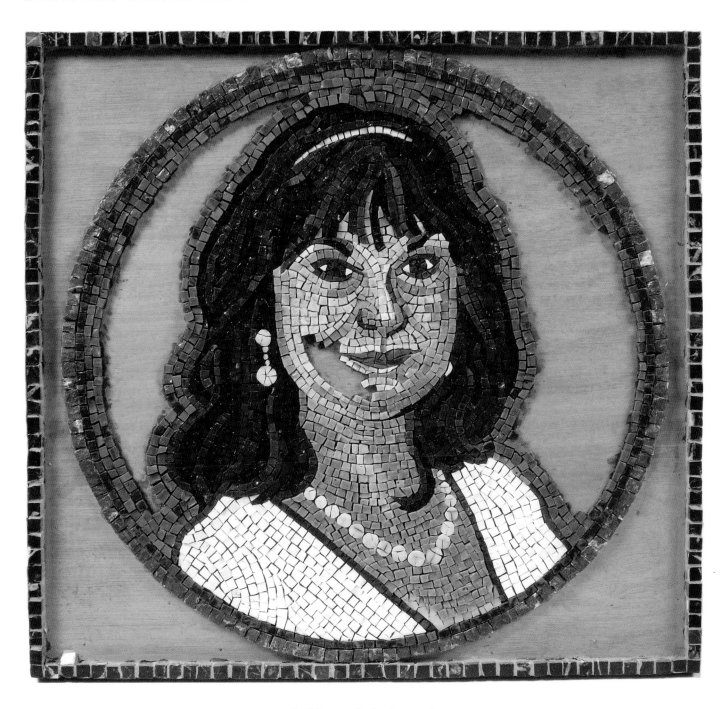

Building up the background.

permanently fixing it in the stiff mortar. Slowly, given the variations in colour tone of the smalti used, the face is built up. Be aware of any light sources that the work may be seen in, and any features you may wish to enhance or hide! This is a self-portrait, after all …

Choose a rich colour for the background. This deep crimson smalti was some I had as a gift from the mosaic artist Hildegaard

Nicholas and which had belonged to her tutor, the revered Hans Unger. It was made by old Ugo Dona from Murano in Venice, a great master of smalti making – a genuine wizard with pigment and fire. This element of personal indulgence can, I am convinced, be justified in a self-portrait, usually a work kept by the artist as part of a personal collection and the precious materials used can therefore be permanently treasured.

The Finished Work

The black marble background hints at its Hellenic inspiration, as early Greek images were created against a dark ground. The flashes of pink gold in the central background are of a marvellous and rare gold, again a gift to me and from Maestro Lucio Orsoni. For me, they add a unique and special value, deeply acknowledging all the support and friendship he and the great Venetian firm of Angelo Orsoni have given not only me but all mosaic artists and mosaic installations around the world that incorporate the firm's superb and uniquely characterful handmade smalti and gold.

Addendum

As an addendum to the creation of a self-portrait, I have added this recently completed reclining self portrait to give a further

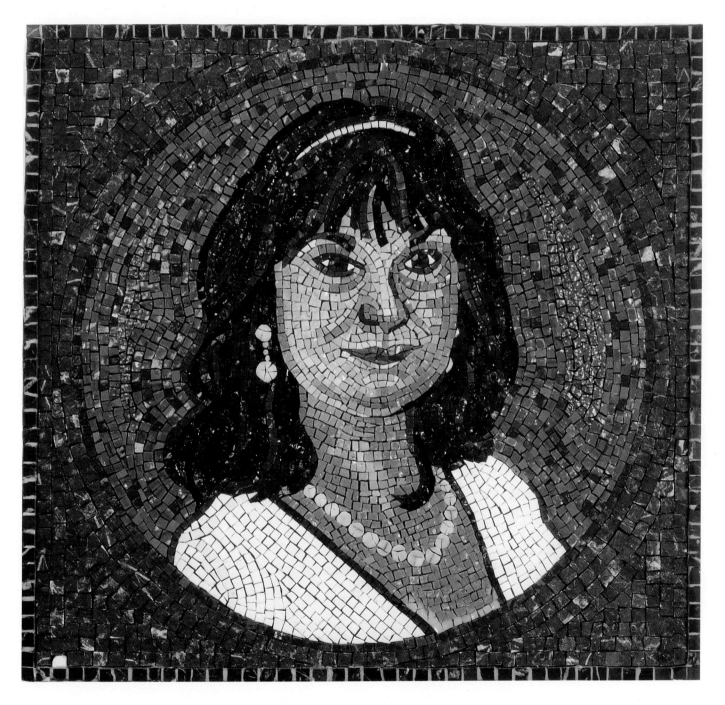

The finished work – ELAINE 2007.

insight into the genre. I have personalized the mosaic further by adding a hammer and hardie, with a few pink tesserae on it, silhouetted against an arched shape in the background. This is a characteristic shape of one of the arcades in my home and studio in Marrakech, Morocco – a more fitting place in which to recline in splendour!

In Greek mythology, Danaë was the daughter of King Acrisius of Argos, who, it was foretold, would lose his life to his daughter's son. So, fearful of the prophecy, he imprisoned his daughter in a bronze chamber for life, to keep away all possible suitors. Undaunted, however, Zeus, indomitable king of the gods, determined to seduce her, visiting her as a shower of golden rain. She bore a son, Perseus, who eventually fulfilled the prophecy.

Titian (Tiziano Vecelli) c.1485–1576, was a Venetian and a pupil of Giovanni Bellini. He was a supreme painter, known especially as a great colourist. His paintings, specifically figurative, seem folded in light; outlines of form are dissolved and feeling is particularly expansive.

In his maturity, Titian did a series of paintings that paid great homage to Woman. This wondrous painting, of which he made at least four other versions, was painted in Venice and Rome between 1544 and 1546. The legend of Danaë, with its obvious erotic overtones, is a subject that has intrigued countless artists besides Titian, such as Correggio, Tintoretto, Rembrandt, Tiepolo, Rubens, Girodet and Klimt. In essence, Titian's *Danaë* is a painting of sensual anticipation, painted with great freedom in terms of

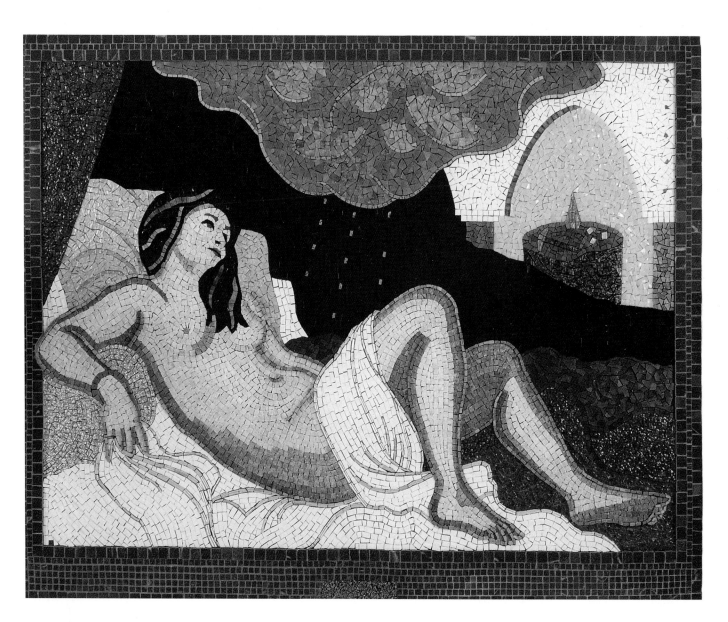

RECLINING SELF-PORTRAIT **by Elaine M. Goodwin, 2007 (after Titian's** *Danäe***), 107 × 138cm (42 × 54in), gold and coloured metallic gold-leaf smalti; Venetian glass smalti; marble (***bianco afioni, rosa portogallo aurora, rosso Verona, rosso laguna***); porphyry.**

technique and colour. It has haunted and delighted me for years, with its exquisite painterly handling and the easy languor of the composition – at once erotic and intimate, yet strangely distanced. In interpreting this painting (with obvious mischief and irony) as a self-portrait in mosaic, a specific challenge faced me: how to change the painting, with its masterly blending of colour and harmony, into one of essentially linear modulation. I sense that this may be the first of a series of attempts …

DANAË, by Titian, c.1545, 120 × 172cm (47 × 68in); oil on canvas, National Museum and Gallery of Capodimonte, Naples, Italy.

PROJECT EIGHT – *RAMA*

History

There was no distinction between representing the gods and representing the mortals in antique times. Great athletes were revered as living heroes, veritable gods, and their feats gave artists a rich source of figurative imagery. In Roman times, mosaics featuring athletes were most often to be found in the large bathhouses of private villas, alongside other popular motifs depicting circus spectacles and hunting scenes.

Inspiration

There is not one, but two, striking and very personable mosaic busts in the Aquileia Museum. They have been lifted from the *terme* or bathhouse floors at the villa north of the town of Aquileia. Their different facial characteristics lead the viewer to infer that they were portraits of much-heralded athletes of the day. In each case, a distinguishing mark – a topknot of hair – signifies a professional athlete, and it seems fair to assume that they were as well-known and applauded as our athletic heroes today.

The gritty strength of the younger athlete is determined in the purposefully drawn line of the mouth, caught by a slight turn of the head. This determination, counterbalanced by the large warm eyes, conveys an inner strength of character alongside a pure physical strength.

My elder son Rama, named after the hero of an epic Indian story, the *Ramayana*, is, at 6ft 4in, a striking and powerful presence, with great strength of character and purpose. His eyes, too, convey great warmth and inner strength – a veritable rock of a personality.

RIGHT: HEAD OF AN ATHLETE, **third century** CE, **from the hall of the Thermal Baths, Museo Archeologico, Aquileia, Italy.** Photo: Elaine M. Goodwin

LEFT: ATHLETE AND HIS VICTORY SYMBOL, THE PALM BRANCH, **fourth century** CE, **from the Baths of Caracalla, Museo Nazionale Romano di Palazzo Massimo, Rome, Italy.** Photo: Elaine M. Goodwin

ABOVE: **Rama, 2006.**

BELOW: **Spray-fixing the drawing.**

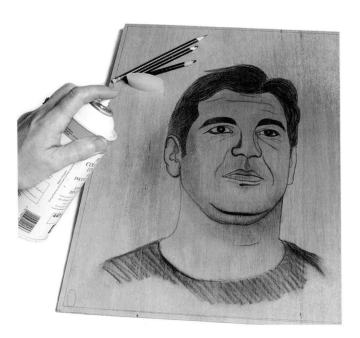

Drawing

Materials

▓ 12mm (1/2in) plywood, 51 × 41cm (20 × 16in)
▓ pencil
▓ charcoal pencil
▓ putty rubber or eraser
▓ spray fixative

The original portrait was contained within an octagonal border, but I have chosen to draw this portrait onto a slightly rectangular board, which will be framed simply at the end.

Draw the outline first in pencil, then strengthen it with an overlay in charcoal pencil. Do not be disturbed if you seem to create a rather insensitive result. This is a *working* drawing for a mosaic that needs to place emphasis on particular features. It takes time to learn how to highlight certain characteristics within a working drawing, which will then be transposed step by step into tesserae. The drawing often looks strangely artificial and forced.

The materials for this mosaic will be marble, which will soften any rather stark initial charcoal drawing and will soon give dominance – determining areas to be enhanced or muted with colour or directional flow. In this particular portrait, it is the strength of character that needs to be conveyed, so be firm with your drawing – no feathery lines and hesitant strokes. When satisfied that you have created a strong mosaic cartoon, fix the charcoal using a spray fixative. This will stop any smudging of the charcoal pencil as you work.

Application

Materials

▓ various cubes of marble, for example black (*nero marquinia*); red/brown (*rosso laguna*); red-pink (*rosso Verona*); deep red (*rosso travertine*); soft green (*verde laguna*); whites (*bianca carrara; bianco statuario; bianco crystalline*); rich warm yellow (*giallo reale*)
▓ hammer and hardie
▓ narrow palette knife
▓ colour pigment
▓ PVA adhesive/white glue and container

Cut the black marble cubes in half on the hammer and hardie. Cut in half again to form narrow rectangular shapes, which,

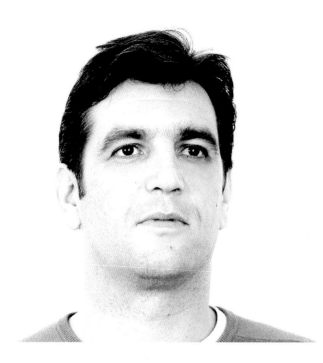

ABOVE: Rama. Use a black and white photo to accentuate the contrasting tones.

BELOW: Building up the eye area, hair, nose, chin, and also the singlet.

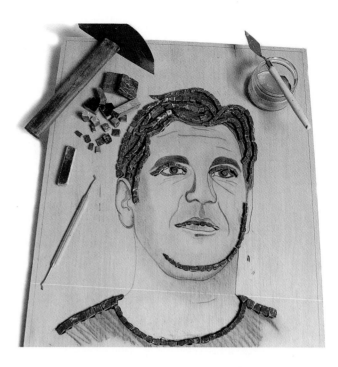

ABOVE: Tessellate the darkest features with the black marble tesserae.

BELOW: Begin to build up the face.

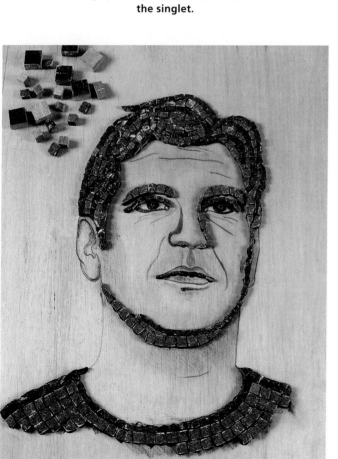

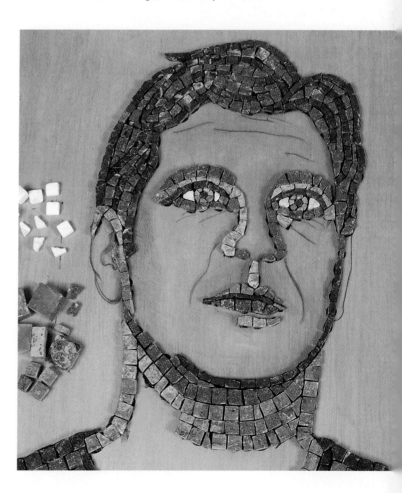

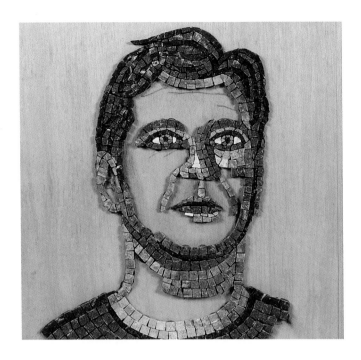

ABOVE: **Continue building up the face.**

BELOW: **Building up the face tessera by tessera is a step-by-step process. Start working also on the background.**

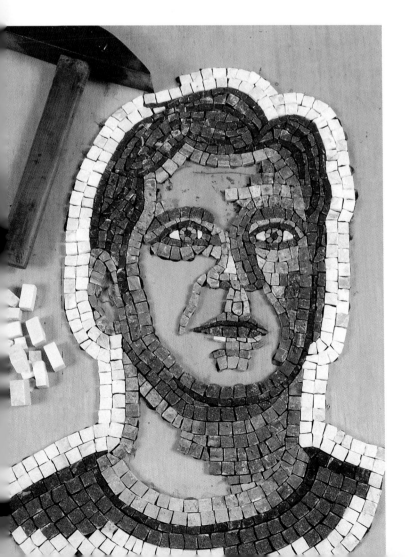

when put together, create a running line with which to outline the strongest facial contours, such as the eyes, chin and hair.

A strongly contrasting black and white photograph or digital image of the sitter can be very helpful at this early stage of the portrait's creation, in order to ascertain areas of light and shade. This is frequently the essence of a successful mosaic work, giving it visual strength and clarity.

Rosso laguna marble is a beautiful crystalline marble and darkly rich in colour. It is an ideal choice of marble for the hair and eyebrows, and for shading where it is darkest, for example around one side of the nose and under the chin.

The reddish-pink marble of *rosso Verona* is an often-favoured choice of mine. Its range within itself runs from soft pink to a deep terracotta colour. It is a wonderful and accommodating marble to depict subtle fleshy tones.

Begin to modulate the area between the eyebrow and the eye itself, the side of the nose, and the ear and neck.

Use the dark, crumbly *rosso travertine* for the line under the eye and lower lip. I have continued to use *rosso Verona* to create the pupils of the eyes, and have completed this crucial area in white with the crystalline *bianco carrara* – now the portrait looks out at us.

Continue to use the marble *rosso Verona* when building up the facial features. The wonderful colour gradations within the material are used to advantage. Surround one side of the face and chin with the darkest shades, and also one side of the nose and the ear.

Introduce the honey-coloured *giallo reale* into the mosaic below the eye and the neck region. The build-up is slow and quite tentative, each added tessera adding character to the whole.

Work a line of tesserae on the left-hand side of the face in a mid-flesh colour, then add a few tesserae at the neck, forehead, under the left eye and on the right cheek. Also add shadow lines below the mouth and above the lip. Use whole or semi-whole tesserae where you can. In this way, a strong tessellation is achieved and tenuous links are made with the mosaic 'realism' so beloved of the Romans, who were great observers of the natural world. Roman mosaics were never slavish painterly copies.

In many Roman mosaics the image is surrounded by one or two lines of tesserae, after which the background is generally completed with lines of horizontal or occasionally vertical tesserae.

Complete the right-hand side of the face, using a few *giallo reale* tesserae alongside the *rosso Verona*, particularly in the centre of the forehead and around the mouth area – also add a few more at the neck. These lighter areas give a gentle three-dimensional effect that alludes to the shade and light movement over the face.

I have added two lines of tesserae at the borders of the mosaic. This work will be framed with a simple, additional frame with

Continuing the facial modulation and background build-up.

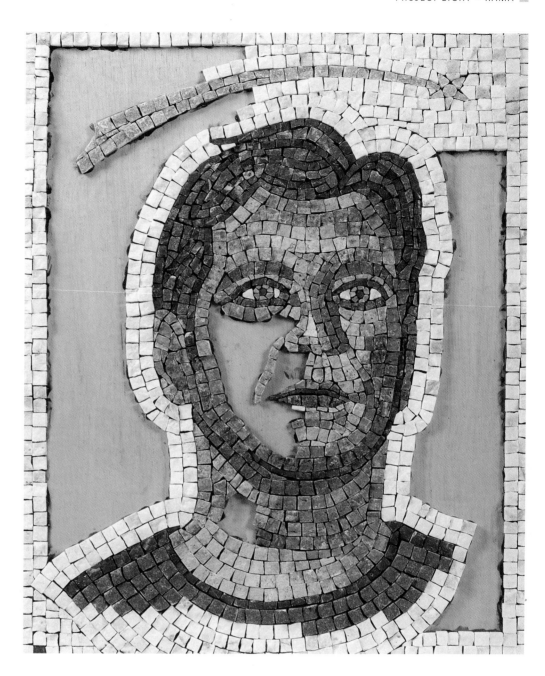

attached lines of mosaic to emphasize the 'framed' nature of an *emblema*, as in the Roman original.

In the space above the portrait I have added a symbolic attribute – an image of a soaring star – in a soft crystalline marble, *verde laguna*. It is a variant of a motif used in a much earlier portrait of Rama. This helps to personalize the work, in true Roman tradition. Athletes were often accompanied by a palm frond or victor's crown, with mythological figures often appearing with identifying symbols, such as Orpheus with a lyre, or *cithara*.

Create for yourself an appropriate attribute for the portrait sitter.

The Frame

The idea to frame this portrait came from a direct link with the original mosaic, which was an *emblema*, that is, a smallish floor panel positioned within a larger, often geometrically decorative scheme. The *emblema* was frequently carried out in a localized workshop, or *officina*, and then placed in position on site. The Romans excelled at this, producing exquisite panels, especially of a figurative nature, composed of smaller, more intricate work to give enhanced detail.

This unadorned bought frame of polished aluminium leaf over wood has a flat surface, so is ideal for working on. The simple

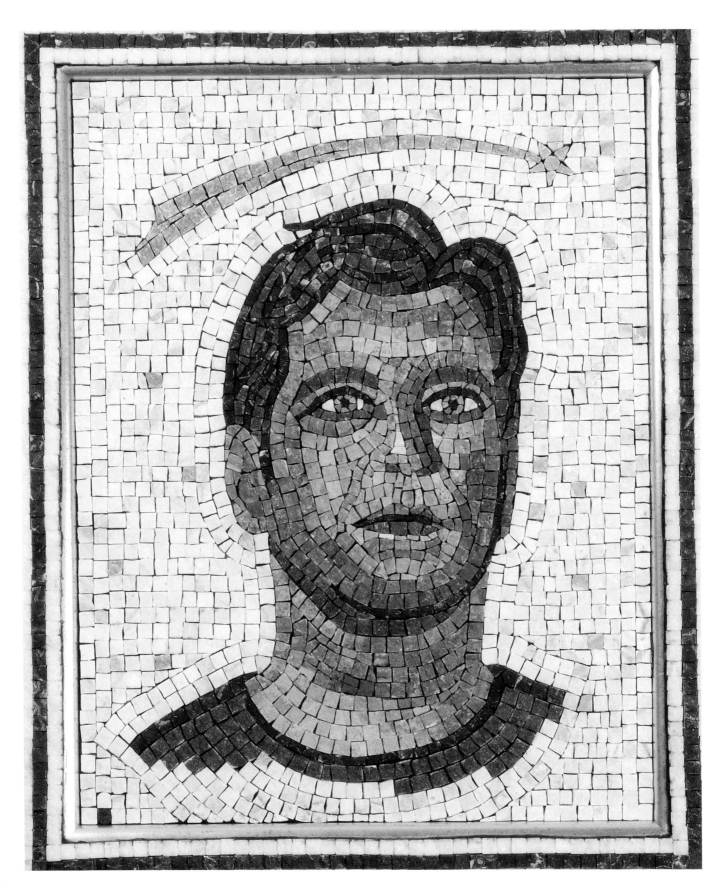

The finished work – RAMA, 2007.

linear design, made up of black and white squares, is sufficient to contain the portrait.

The Finished Work

The finished work is rich with colour from the beautiful marbles of Italy. The result is a portrait of both resemblance and aspiration.

Additional Mosaic Portrait

This early full-figure portrait of Rama was initially created for one side of a corner bath in a family bathroom. The simple linear black on white design was made up of unglazed ceramic tiles and grouted to give a waterproof surface. The star in ascendancy was introduced to give a symbolic significance to the future – an appropriate symbol to accompany a young life.

RAMA, AGED 10, **1983, 138 × 54cm (54 × 21in), ceramic and vitreous glass.**

EMPRESS THEODORA AND HER RETINUE, **sixth century** CE, **San Vitale, Ravenna, Italy.**
Photo: Elaine M. Goodwin

PROJECT NINE –
BETHANY

History

In Roman antiquity, the portrait was one of the most enduring and successful of art forms. The style termed 'late Roman', which was imported into Egypt (the site in the Fayyum Oasis in the Nile Delta is famous for this), was inherited from tomb paintings where portraits of the deceased were depicted on wood. They were characterized by an austere linear modulation, with flat areas that had a tendency towards an abstract quality. The most memorable feature in these works was a magnetic gaze, consisting of large, fixed eyes.

This style for portrait work was very fashionable until the fourth century CE and it is very probable that it became the direct precursor of Byzantine icons and mosaics, early examples of which can be seen in the mosaics of Ravenna in Italy, particularly in two large and unique secular dedicatory framed panels in the wonderful mosaic-encrusted basilica of San Vitale. One panel depicts Justinian, the great Byzantine emperor, with his entourage, while the facing panel is of Empress Theodora, his consort, with her retinue.

The two figures on the Empress's left side, as opposed to all the other figures, are certainly portraits of court ladies. They have expressive faces, unlike the richly colourful, huddled anonymous group on the far right of the picture. It is generally acknowledged that these figures are representations of Antonia, the wife of General Belisarius, conqueror of the Goths, and his beautiful daughter, Giovannina. This latter is an image of sublime presence.

It is generally accepted that early Byzantine mosaic artists specializing in figures or faces divided up the work to best illustrate their particular virtuosity. Heads were probably first sketched on canvas, away from the site, where they were built up using smaller tesserae than the other panels of the mosaic, and were then transferred to their allotted position on the mortar. The mortar would have consisted of chalk and marble dust, egg white and water, with linseed oil added as a binder.

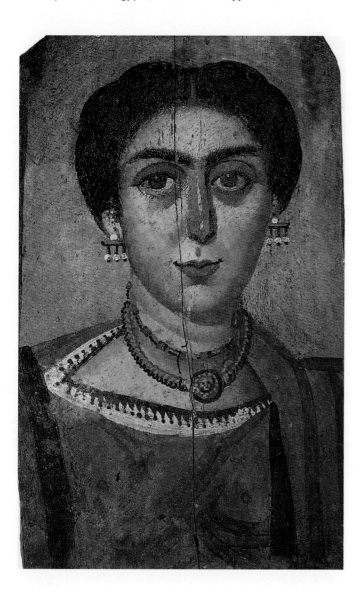

YOUNG WOMAN, **mummy portrait, Romano-Egyptian, fourth century CE, Kunsthistorisches Museum, Vienna, Austria. Photo: Elaine M. Goodwin**

Inspiration

The frontal posture of the young Giovannina is arresting. She is exquisitely robed in a rich shawl of red and green on a gold ground, over a robe decorated with small flower buds. Her bejewelled face is of sumptuous and timeless beauty. Her dark eyes, under black brows, gaze at the viewer in a pose of calm reflection.

Since she was born, my brother Adrian's beautiful younger daughter Bethany has gazed on the world in such a way. I am struck by the similarity of expression that she, aged twenty-one, holds to that of the courtly Giovannina, as she observes a very different world nearly 1,500 years later.

Drawing

Materials

- 12mm (¹/₂in) plywood, suggested size 46 × 46 cm (18 × 18in)
- 3B/4B pencils
- putty rubber or eraser

Translate the photographic portrait into a simple line drawing. This can be done naturally by eye, or by enlarging a photographic print to the required size and transferring it to the board by squaring up the photograph to equate to a drawn grid on the timber backing. Another method is simply to trace over the picture straight onto the backing board, using carbon paper in the middle. Emphasize the eyes in the drawing, the direct and deep-set gaze, the aquiline nose and the line of the mouth.

LEFT: **'Giovannina, Daughter of General Belisarius'**, detail from panel of EMPRESS THEODORA AND HER RETINUE, *c.*550 CE, south-east apsidal wall, San Vitale, Ravenna, Italy.

BELOW: **Bethany, 2006.**

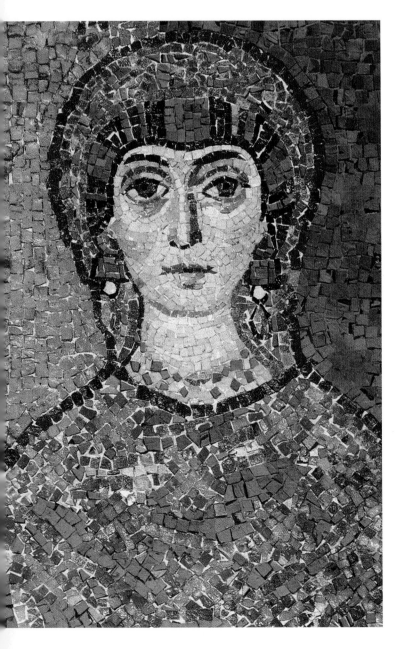

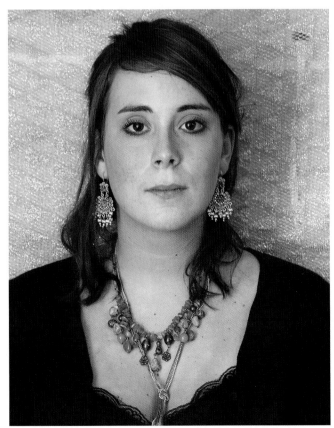

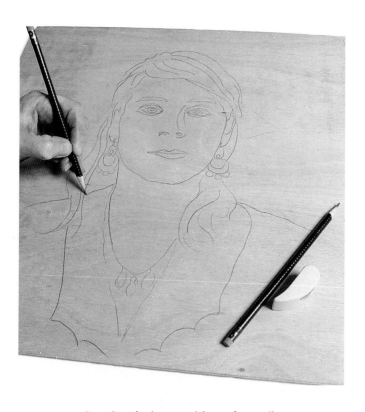

Drawing the image with a soft pencil.

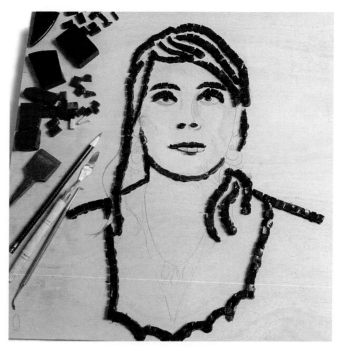

ABOVE: Outline the form, using black and red smalti.

BELOW: Using flesh-coloured smalti, begin to outline the main features.

Application

Materials

- various colours of marble and smalti (the palette of the original Byzantine portrait is made up of reds, green, violets, black, white, golds and flesh tints)
- gold and silver leaf glass (undulating and plain)
- silver and black highly glazed tiles
- Ravenna mirror glass
- mother-of-pearl
- selected beads and miscellaneous semi-precious jewellery
- coppery-gold ink/pigment
- black pigment
- ready-mixed cement adhesive
- mosaic nippers
- hammer and hardie
- prodder/dental tool
- small palette knife
- brushes
- containers
- water

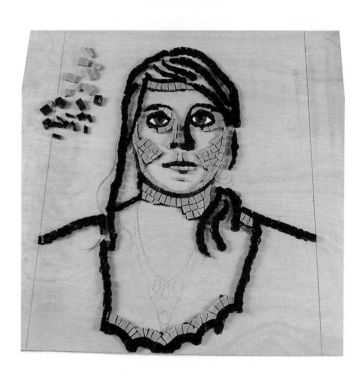

Cut the black mosaic smalti in half and 'draw' the eyebrows, pupils, nostrils, hair and the line of the shoulders. Cut the red mosaic smalti into thin running lines and outline various areas of the face, the chin and mouth.

BYZANTINE MATERIALS

It has been observed that in this early period of mosaic development, semi-precious jewels, like lapis lazuli and lustrous mother-of-pearl, usually shaped in roundels, were used for both ornamental texture and to allude to the richness of the period in both spiritual and materialistic terms. The fibula fastening Emperor Justinian's cloak, on the panel facing that of Theodora, was known to have been a large and precious jewel; today it is a large chunk of scarlet smalti.

Most Byzantine work was executed in glass smalti, an exquisite, richly coloured material with an uneven, faceted surface and gem-like precious quality. Marble or natural stone were also introduced for use on the hands or faces, to create areas of soft, luminous flesh. This use of marble and its softening effect adds a wonderfully humane quality to a work. The use of glass smalti throughout would have resulted in a more brittle final effect. Using mixed media creates an extraordinary ambiguity between humanely individual secular portraiture and impersonal courtly remoteness.

From about the fifth century, jewels and ornaments were often depicted using additional materials, such as Venetian gold and silver leaf. This recreated a sense of preciousness and imparted a dazzling and reflective brilliance to the work. Uniquely, tesserae of mother-of-pearl were also introduced at this time in the mosaics of both churches and mosques, as, for example, in the great Mosque in Damascus, Syria. This nacreous material introduced a softly glowing effect, ideal for decorative beaded curtaining, jewellery and diadems. By a thoughtful mixing of materials, a very refined understanding of them was reached, from which we are still learning.

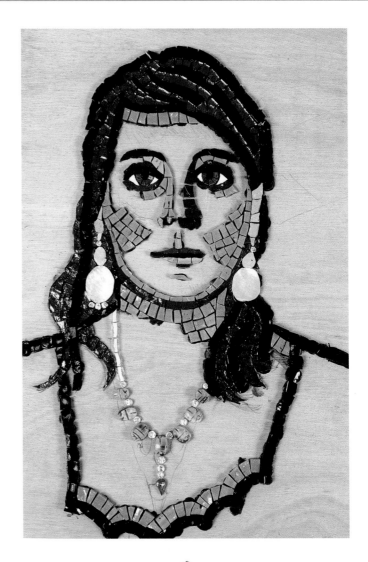

Key to Miscellaneous selection of materials.
1. Mother-of-pearl; 2. White gold; 3. Ravenna mirror glass; 4. Granulated white gold leaf; 5. Scarabs (small glazed objects from Egypt); 6. Costume jewellery gems.

Adding jewels and cut mother-of-pearl pieces.

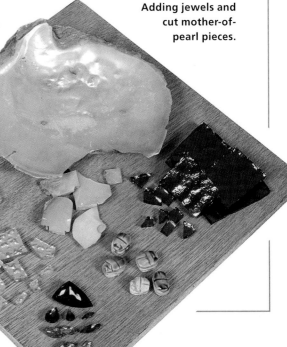

Miscellaneous selection of materials used in the portrait.

RIGHT: **Detail of the upper part of the face showing the coppery-gold colour added to the adhesive.**

BELOW: **Cutting the marble *rosa portogallo*.**

BELOW RIGHT: **Designing a border.**

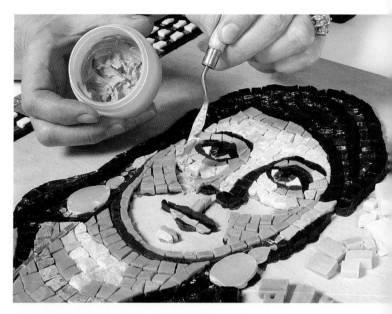

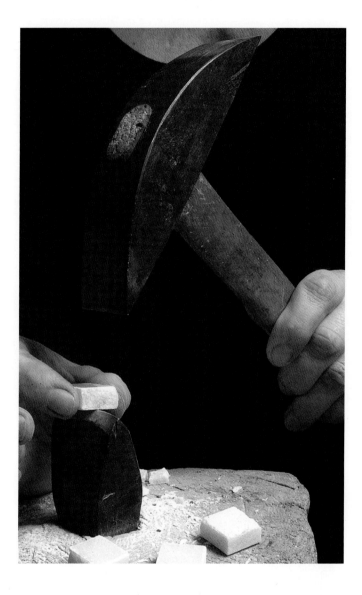

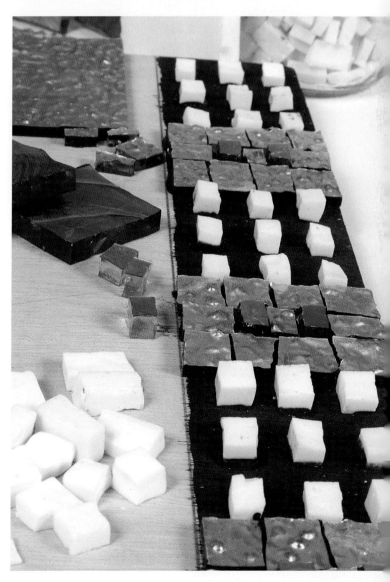

To fix the tesserae to the backing timber, add water cautiously to a ready-mixed cement adhesive to create a cement paste, adding a small quantity of black pigment to colour it. Mix well. Spread a small amount onto the board, using the palette knife. Each smalto should be pressed into this mixture up to at least half its thickness.

With the darkest red colour, add a deep shadow for the nose area, then with the same colour mark the lower eye line.

Use a dark flesh-coloured smalti, cut mainly into three latitudinally, to build up the contours of the face. Emphasize the cheek area, the other side of the nose, the area below the brow

and under the eye to enhance the almond shape. Continue by adding a line of dark flesh colour at the hairline, chest and neck.

I have used a medley of silver, glass-paste jewellery, mother-of-pearl and Egyptian glazed scarabs to use as my jewellery additions. For the hair, I have used Ravennese mirror glass of a golden brown colour, to add reflecting lights and to link the portrait with its inspiration in San Vitale in Ravenna – only one hundred steps away from where the material is made.

The marble used for the lightest area of the face in order to give a special luminescence and 'softer' quality is *rosa portogallo*. It is a particular favourite of mine, but it needs careful attention, being very crystalline and quite soft in structure.

When cutting the marble, be sure to bring the hammer down firmly, at a 90-degree angle, onto the tesserae. Check that you are holding the hammer well down the handle, to give more force to the blow from a good wrist action. The marble is partly translucent. I like either to paint the board white before laying the tesserae or, as in this instance, make up an appropriately coloured adhesive. Here, a little warm-coloured pigment or ink of a coppery-gold hue is mixed with the PVA adhesive and applied either to the backing board in small sections, or to the tesserae before laying. It provides a lovely background colour that glows through the tesserae at their most translucent.

Carefully run a line or two of tesserae up the centre of the nose and below part of the eye. Extend it into a row or two of tesserae over the brow and lower forehead. A 'shadow line' of darker flesh-coloured tesserae at the hairline frames this upper part of the face. Leave any areas you are uncertain about. Keep standing away from the portrait and allow the face to 'speak' to you, that is, slowly the face will become alive, each tessera adding something to the whole. In this manner, we are building up a dialogue between materials and textures and colour. Use light, flesh-coloured smalti to work on one side of the face, both to retain the luminescence and to provide a variety of textures in true Byzantine fashion.

Start to think, too, about the background. This will be made up of gold tesserae, in a similar Byzantine manner.

In this very decorative portrait study, it seems highly appropriate to add an ornamental border. The original sixth-century secular panels were framed with a jewel-like border design. I have adapted the design to use in two parallel vertical columns on the left- and right-hand sides.

BYZANTINE ARCHITECTURAL DECORATION

It is very rewarding to study early and middle Byzantine period ornamental decoration, from the fifth to the twelfth century. At every opportunity, every facet of a church architectural interior – window arches, lunettes, apse, dome and soffits – was covered with innovative decorative designs, in colour combinations which astound and delight, and which help to modulate and link the curves and forms, giving spatial identity to the new architectural forms, acknowledging their three-dimensional nature within a narrow picture plane. There is little or no perspective to give space around or behind forms. The decorative articulation helps cohesion of the space, giving just enough distinctiveness to include the viewer in understanding the whole design and its didactic narration.

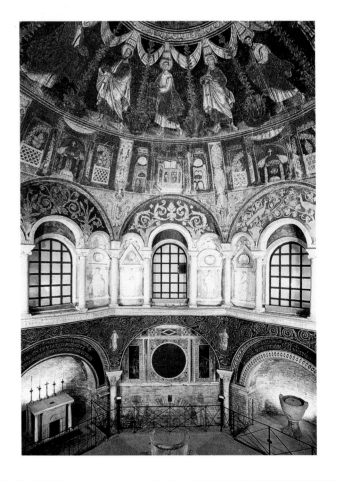

The mosaic decoration intimately fused with the architectural structure, detail from the NEONIAN BAPTISTERY OF THE CATHEDRAL, **fifth century** CE, **Ravenna, Italy. Photo: Elaine M. Goodwin**

Working on the chest area of the portrait.

Build up the neck and chest area with lines of flesh-coloured smalti and marble, adding a hint of lighter marble. Use a dark, warm-coloured smalti at the dress line – again to frame the flesh-showing area. Within the black garment area, add a little detailing of similar colour but of different texture, for example a highly glazed tile; this introduces a little textural interest into the large expanse of one colour, while continuing the decorative quality of the mosaic.

Byzantine Colour Modulation

I have modified the colour used in the face from that of the original, since this work will be seen in a much more intimate setting – a room or a gallery. Originally, colours were used in such a way as to be seen strongly from a distance. There was very little use of subtle tonal modulation (unlike much Greek and Roman work, which was seen at close quarters on a floor) – more a juxtapositioning of closely related colours that either contrasted or merged on the retina of the eye to give colour blending. Contrasting

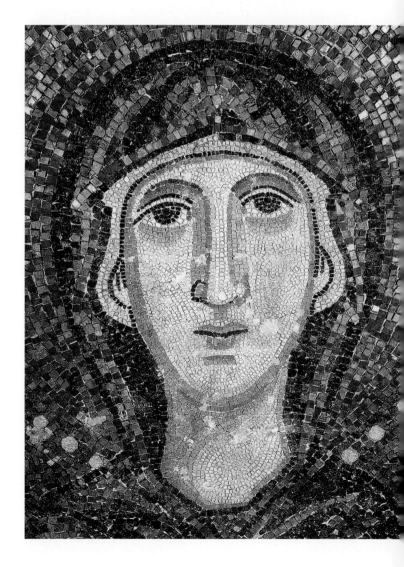

HEAD OF THE VIRGIN MARY FROM THE ASCENSION, *c.* ninth century CE, Hagia Sophia, Thessaloniki, Greece. A blend of marble, glass smalti, gold and mother-of-pearl. The juxtaposing of green and blue tesserae provides dark shading when viewed at a distance.

Working on the background.

Self-portrait, ELAINE, 2007. A mix of vitreous glass, glass smalti, copper, gold and silver, to give a surface of mixed reflective intensities.

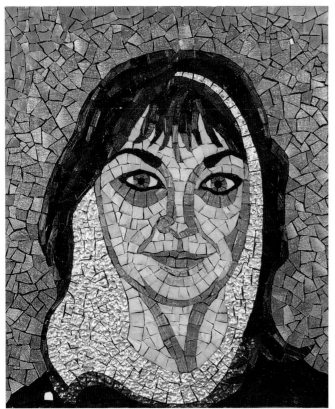

as in the hands and face, light tones of marble were used. The Byzantine *pictores imaginarii* and *musivarii* – painters and mosaic workers – had a great understanding of colour effects. They knew the qualities of each material in depth, displaying this virtuosity for utmost effect.

There are numerous examples of Byzantine mosaic works around the Mediterranean where examples of this advanced understanding can be enjoyed.

The background to most Byzantine mosaics is gold – a rich, shimmering surface of light. Begin to surround the portrait with slightly larger golden tesserae, in a mixture of different surfaces – smooth or gently rippling, and occasionally including tesserae of mirror glass.

Work up a background that is fairly regular in size and shape, to provide a brilliantly glowing support to the luminous portrait.

The Finished Work

The portrait is resplendent in sumptuous golds, smalti, jewels and textured marble: it becomes, in effect, a neo-Byzantine secular icon.

Postscript

It was truly a technical refinement to place marble and glass deliberately side by side. It should be acknowledged that from

colours helped the viewer to 'read' the detailing. Depth and plasticity of form occurred from distance viewing, by optical blending where the eye merges the separate lines to allow the illusion of the 'real' form to emerge. Colour made up of glass smalti was intense, and richly chromatic, and where luminosity was needed,

this point the inherent value of each material was exploited – mosaic had become an art form in its own right. This true understanding of the *abstract* qualities of the material was identical in content and enquiry to that of twentieth- and twenty-first-century artists, who explored, and continue to explore, the abstract qualities of light and colour in their paintings, sculptures and mosaics. Such clear artistic insight, so consciously calculated, has to be celebrated.

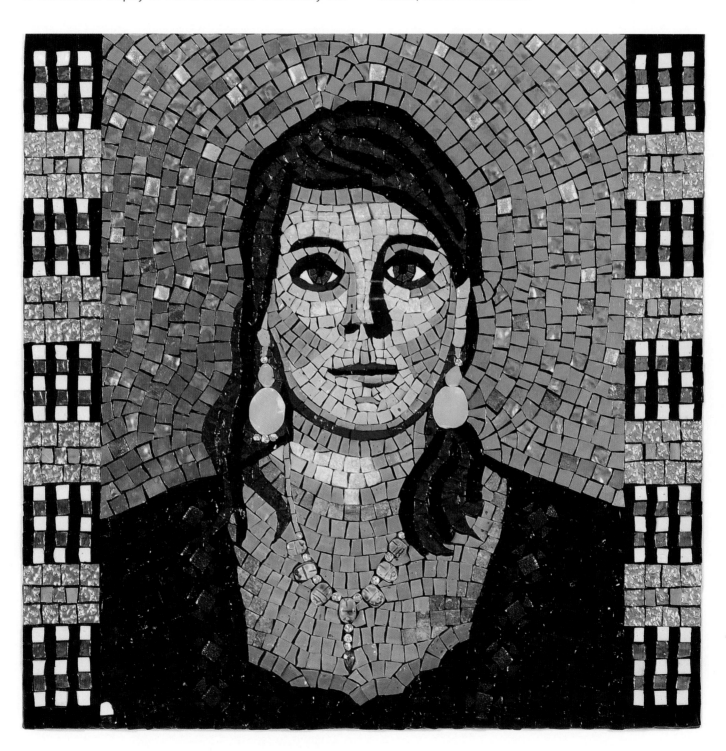

The finished work – BETHANY, 2007.

LIFE OF ST AIDAN by Sir Frank Brangwyn (1867–1941), 1919, apse, St Aidan's Church, Harehills, Leeds, England.
Photo: Elaine M. Goodwin

PROJECT TEN –
DARIUS

History

This was the only mosaic mural the artist Frank Brangwyn made, taking over ten years (1897–1910) from conception to completion. As a young man, Brangwyn was apprenticed to the British craftsman and designer William Morris, and produced designs for carpets, wallpaper and tapestries. He absorbed something of Morris's philosophy that art should be 'for the people' and was essentially 'a skilled craft'. Later, Brangwyn became influenced by Venetian art and his work developed rich colour combinations, but with a linear delicacy. As a member of the Vienna Secession from 1897, he obtained many mural commissions. Always devout, he believed his art was to glorify the Divine.

The original design for the apse was to have been of tempera – a fresco painting – but the qualities of permanence, luminosity and richness of colour inherent in the medium of mosaic were eventually deemed more appropriate and effective in a smoggy, northern industrial city.

Forty local women were trained by the glass painter Sylvester Sparrow to work on the large project. Brangwyn's cartoons, which are now housed in the monastery of St André in Bruges, Belgium, the birthplace of the artist, were used in a reverse technique. The women cut the tesserae – a vitreous glass made especially by the Rust Company in Battersea, London – and temporarily glued them upside down onto brown paper templates. On completion, each template was placed into its designated position in the apse on a prepared and numbered cement screed. When secured, the brown paper was washed off and the mosaic surface was grouted with cement to reveal a unified, fairly smooth and altogether stunning mosaic.

The continuous frieze of colour with a strong horizontal emphasis and striking vertical thrusts is both beautiful and arresting. It depicts episodes from the life of Saint Aidan. It is lush and vivid in colour with a uniquely emotive overcharge. It is this – the shock of it, its vivacious and dramatic splendour appearing in a city which, at the time of its making, was smog-ridden and without colour – that never fails to astound and lift the spirit. Marvellous!

TWO YOUTHS, **detail from** THE LIFE OF ST AIDAN **by Sir Frank Brangwyn, parapet wall, chancel (see apse in the background), St Aidan's Church, Harehills, Leeds, England.**
Photo: Elaine M. Goodwin

PROCESSING YOUTH, **detail from** THE LIFE OF ST AIDAN **by Sir Frank Brangwyn, St Aidan's Church, Harehills, Leeds, England.**
Photo: Elaine M. Goodwin

The splendour of the apse mosaic is carried on into the chancel, where the mosaic continues with a variety of processing figures on a rich, dark blue ground. It is here that a certain intimacy and very touching human condition is addressed. Said to depict a quote from the Christian New Testament, 'Come unto me, all ye who labour and are heavy laden and I will give you rest' (Gospel of St Matthew, 11:28), it shows a line of bowed figures, their hands together in prayer.

Standing well back from the mosaic, it can be seen as a whole – a three-dimensionally conceived work of great spiritual breadth. I marvel when I consider that my father, Stanley Herbert Webster (1920–90), was born but a few streets away from this mural, and would have been baptized as a youth in this very church, with the full impact of this extraordinary mosaic mural, freshly unveiled, before him.

Inspiration

This poignant young male figure, with eyes lowered and hands together, has a further resonance for me. My younger son, Darius Alexander, is a jazz pianist. My most frequent sightings of him are at the piano, head bowed in profile, eyes lowered, his hands working the keyboard in a reverie of concentration and inner contemplation. It was the meditative quality of the mosaic work that inspired this portrait of my creative and spiritually motivated younger son.

Drawing

Materials

- 12mm ('/₂in) plywood, suggested size 102 × 40cm (40 × 16in)
- pencils
- rubber/eraser

ABOVE: **Detail of the drawing, strengthened with a fine felt-tipped pen.**

BELOW LEFT: **Darius, 2006.**

BELOW: **The pencil drawing.**

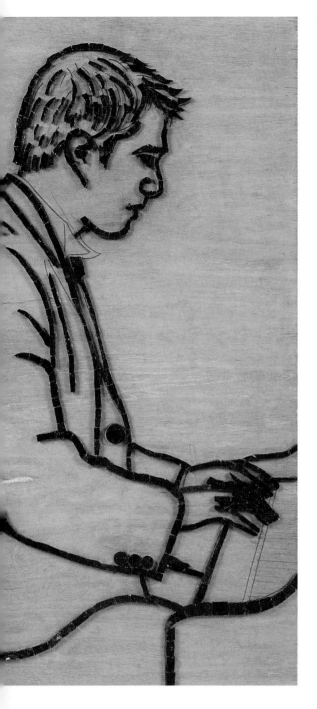

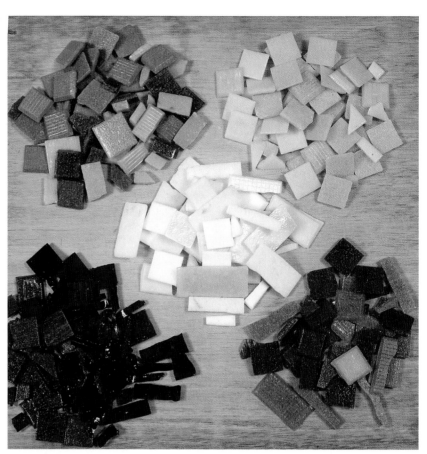

ABOVE: **Materials – a palette of vitreous glass tesserae in various sizes, thicknesses and finishes.**

LEFT: **Outline the whole figure in black glass tesserae.**

- fine felt-tipped pen
- putty rubber or eraser
- ruler
- glass paper/sandpaper

I have drawn Darius, at work, at the piano. Two features dominate; the bowed head in profile and the moving hands. I have chosen a strongly vertical board on which to work, as this shape cuts out extraneous parts of the figure, allowing full concentration on the

head and hands. It is important in portraiture to concentrate on the essential characteristics of the sitter and to give prominence to these features or aspects. Sometimes additional visual attributes will give a deeper meaning to the portrait, in the same way that important personages and saints are often accompanied by their individually recognizable symbols and singular characteristic visual references.

The drawing for the profile should be undertaken with extreme sensitivity and simplicity to underpin strongly a looser mosaic application. In the original, a certain naïveté of random cutting constitutes the work of the Brangwen mosaic.

Sand any rough edges on the wooden backing board to a smooth finish. Work up a pencil design, then, with great care, create a strong outline using a fine felt-tipped pen. Much of the inner area will be made of mosaic of one colour and a prominent black outline will surround the whole. This was the nature of this style of mosaic work in the early twentieth century.

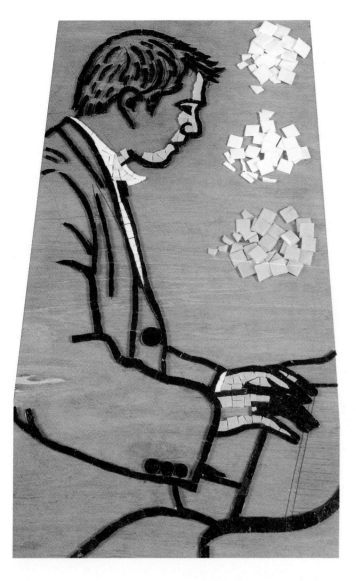

ABOVE: **Begin to fill in the face and shirt detail.**

RIGHT: **Use the inherent shading within the glass tesserae to continue the facial tessellation.**

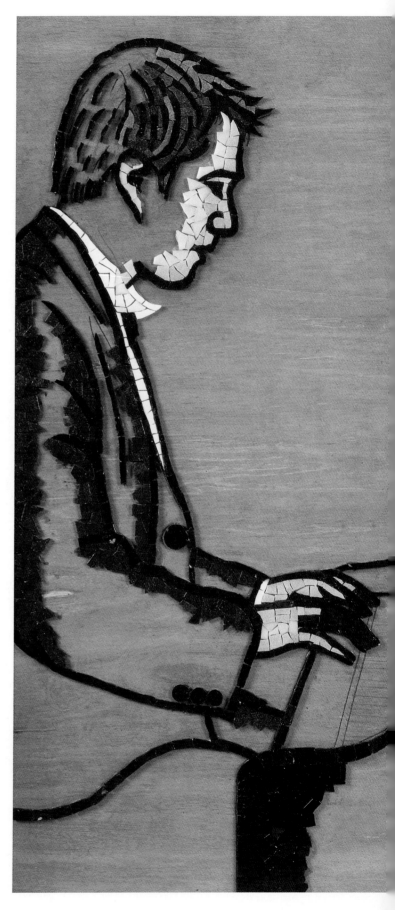

Application

Materials

- palette of black, white, charcoal, brown, ochre, turquoise and flesh-tinted vitreous glass
- wheeled mosaic cutters
- PVA/white glue
- container
- palette knife
- dental tool/prodder

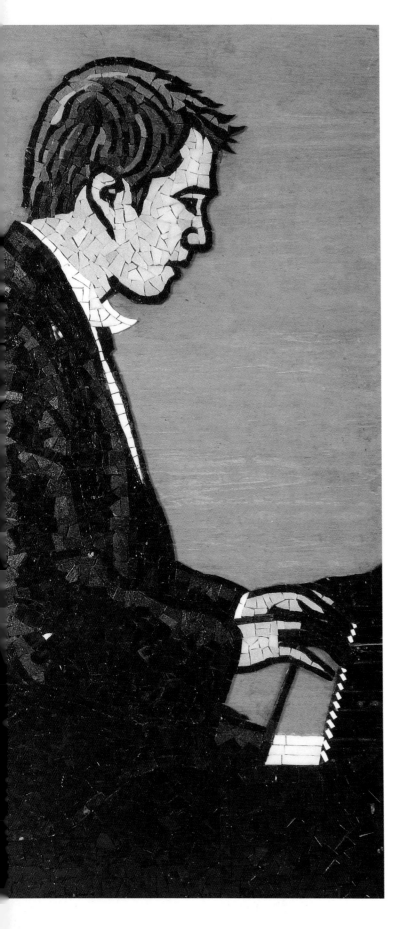

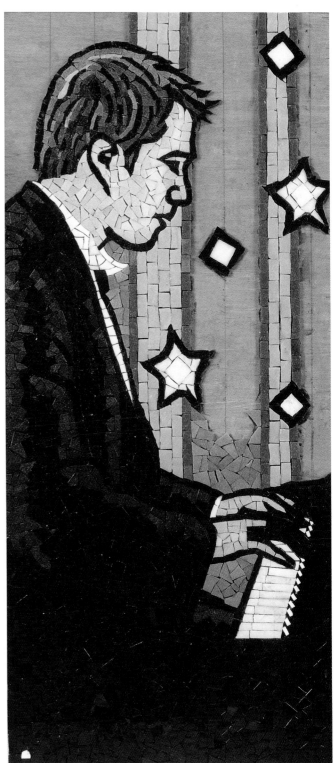

ABOVE: Working up the background with random star shapes and vertical lines.

LEFT: Continue to use a lighter shade of flesh-coloured glass in building up the face. Fill in the dress suit with charcoal and black tesserae of quite large size. Work on the piano keys with white vitreous glass, cut in long and narrow rectangular strips.

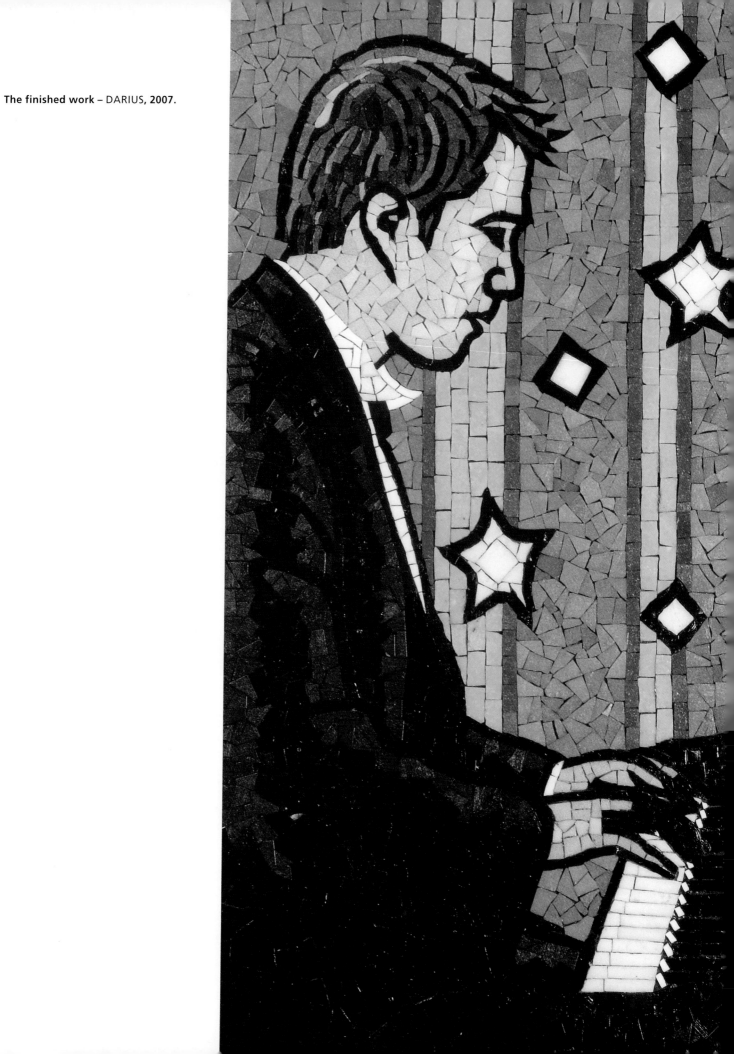

The finished work – DARIUS, 2007.

The face and the entire drawing are outlined in black vitreous glass. The pieces are quite chunky and of various size and thickness, as in the original. Take especial care around the features of the profile. My son was concerned that his ear be strongly featured – I guess for a musician this is a crucial tool of the trade. I have tried to make it look a little like both a bass and a treble clef. With portraiture, you should be free to personalize attributes or accentuate features – but, as ever in mosaic, do this with an underlying understanding of content, to give strength to a work, not merely a whimsical twist.

The whole mosaic, including the face and hands, will be composed of variably sized tesserae of coloured glass, in an opus known as *palladianum*. This is not a classically conceived way of laying tesserae. Known colloquially as 'crazy paving', this seemingly random way of creating a mosaic depends on good tessellation for greatest effect.

The materials chosen for the portrait are of similar quality to those used in the original. The glass is a manufactured vitreous type in a variety of thicknesses and quality, some being quite old and made in Western-Super-Mare in England during the 1950s.

The mosaic glass used in the original work at St Aidan's was manufactured by Rust's Vitreous Mosaic and Tile Company of Battersea in London. It is a very opaque and textured glass in the main, incorporating a lot of sand in its production. At first glance, it is not unlike smalti, with its strong coloration and dense quality, but on closer inspection it compares more to antique smalti, with a far grainier composition and with a wide variety of textural 'imperfections'.

Cut flesh-coloured vitreous glass of various textures in rather larger irregular shapes, but be sure to work with care around the drawn profile to capture the essence of the likeness. Add also the white shades to the dress shirt, which will give just a sliver of brilliance in the overall darkly silhouetted depiction of the figure.

The irregular tessellation in the facial area merges slightly differing colours to give an oblique relief modulation.

Begin to work on the dress suit, with the lighter charcoal-coloured glass, and also work on the shiny, intense black of the piano. Begin, too, to work on the hair in shades of brown and warm ochre. By working on different areas simultaneously, the seated figure evolves and develops rhythms, both independently and as a whole, like jazz music – with independent sections, aware of each other, coming together to make a work of resolved resonance.

The clothes of the seated subject are mostly of black glass tesserae, as are the piano parts except for the keys. This singles out two areas in the portrait of strongest significance – the face and the hands on the piano keys; these instantly identify the sitter as a musician. When working on any portrait you create in mosaic, be aware of deeply symbolic or characteristic features and allow them to enrich and inform the work.

The area left for the background will make strong links with the Brangwyn original. I have introduced five stars, of similar design to those around the processing youth. These add a dynamic quality to the work as a whole, being, in effect, symbolic of aspiration and the celestial.

Whereas the original has a horizontal emphasis to link it with the idea of an earthly procession, I have added a vertical emphasis (a feature so strongly observed in the narrow soaring trees in the apse mosaic). This suits the vertical nature of the mosaic, and substitutes for the curtain present in the photograph. The vertical lines are composed of rectangular tesserae and the infill continues in opus *palladianum* to give a more textural feel.

The Finished Work

The completed mosaic is in essence a portrait of a musician at his work – a man and his music. There is no direct link with the viewer, through eye contact; rather, he is observed and, if we try very hard … heard.

Two Additional Mosaic Portraits

This panel is a simply conceived black on white horizontal portrait of Darius with his then constant 'dog' companion. It was made to correspond with a similarly conceived panel of his brother Rama, to decorate a corner bath in a family bathroom.

This almost full-sized frontal portrait with an exotic fruit was done after I had lived and worked on mosaics in India for six months, accompanied by Darius as a very young boy. It is simply created in tesserae based on the cut cube shape. The strong dark silhouette holds its own against a repetitively ornamental vertical backdrop.

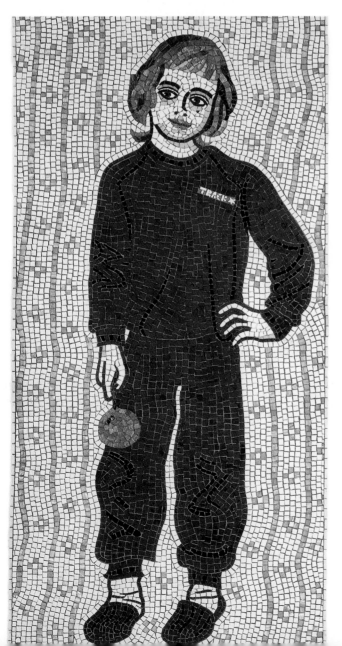

ABOVE: DARIUS, AGED THREE, **1983, 138 × 54cm (54 × 21in),** unglazed ceramic, vitreous glass.

LEFT: SMALL BOY WITH A GRANDILLO **(Darius, aged four), 1984, 60 × 127cm (24 × 50in), unglazed ceramic, vitreous glass.**

HE, 2007, Elaine M. Goodwin, Venetian gold, Carrara marble.

OTHER ARTISTS' INTERPRETATIONS OF THE FIGURATIVE FORM

Introduction

I asked nine esteemed and established artist friends around the world, who work in the mosaic medium, to join me in creating a new work for this publication. Each artist was given free rein to interpret the figurative form as they chose. I have also included an additional personal exploration of the human form. The results are, for me, and I hope for you, an exciting and living testimony to the versatility and compelling stature of mosaic as a medium for contemporary figurative expression.

Robert Field (Swanage, England)

Artist's Statement

I work mainly in ceramic, glazed and unglazed. For a previous figurative series based on the torso, I took Greek sculpture as a

ABOVE: **The working drawing: pencil on a timber backing board.
Photo: Robert Field**

BELOW: **Building up the mosaic tessera by tessera.
Photo: Robert Field**

Robert, Penang, Malaya, 1961. Photo: Robert Field

A GLIMPSE OF THE PAST, **2007, 31 × 40cm (12 × 16in), glazed and unglazed ceramic and vitreous glass.**
Photo: Robert Field

starting point, but for this figure study, *A Glimpse of the Past*, I used a photograph of myself taken almost half a century ago. In order to create a sense of unreality and the passing of time, I decided to limit my palette to white only, with pale grey grout to give the sense of a faded drawing. For more variety of texture and tone, I then incorporated vitreous glass, along with the glazed and unglazed ceramic.

The artist at work in the studio.
Photo: Robert Field

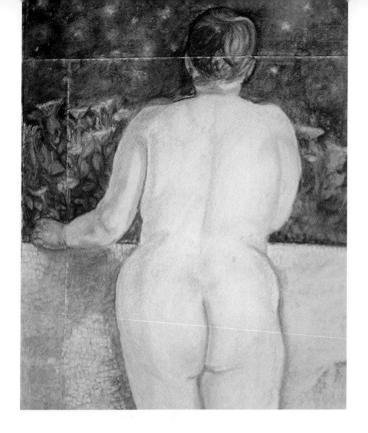

Life-size pastel drawing. Photo: Mirjana Garćević

Copying the drawing onto transparent film.
Photo: Mirjana Garćević

Placing the tesserae onto the adhesive mixed with acrylic
emulsion. Photo: Mirjana Garćević

The artist at work in his studio. Photo: Mirjana Garćević

Milun Garćević (Zagreb, Croatia)

Artist's Statement

Mosaic, for me, is *l'arte di pietra*, the art of stone. I studied painting, graphics, design, textiles, vase painting, sculpture, metal design and architecture to be able to translate them into mosaic – building up a databank and memorizing geometry, abstraction, figure motifs and symbols. This created an inexhaustible source of reference for all my work. Mosaic can be work, play, or passion, but it needs faith and patience. The mosaic language with its symbols and expressions connects all nations, civilizations, cultures and religions. This ancient art will continue until the last tessera is laid in the mosaic of human existence.

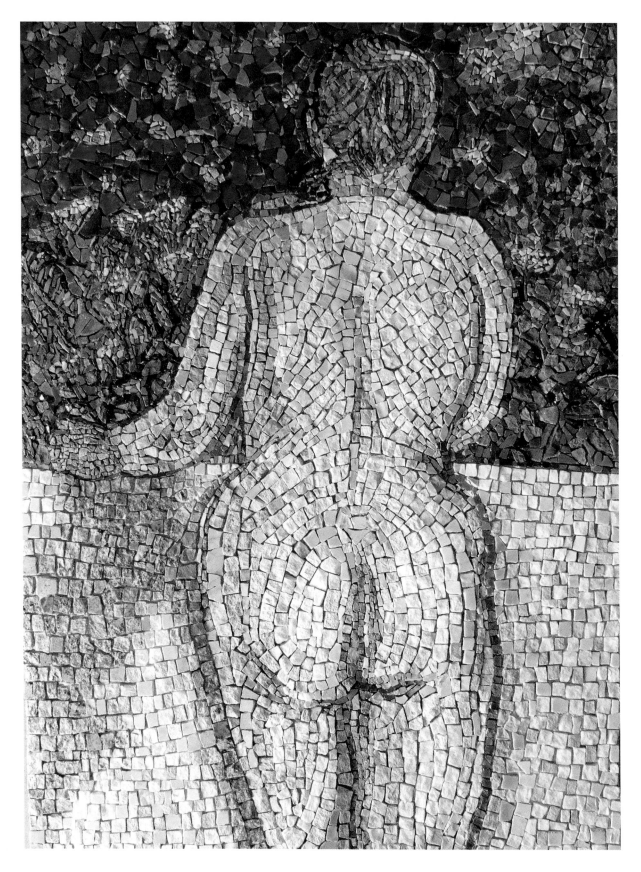

MIRJANA, 2007, 111 × 82cm (44 × 32in), smalti, multicoloured marbles, bricks, tiles, river stone and limestone.
Photo: Mirjana Garćević

Elaine M. Goodwin (Exeter, England)

Artist's Statement

For many years I have questioned the eternal theme HE and SHE – the male and the female in many guises – apart and together; without and within; in essence and in personification. It is a perpetual pursuit, my hammer is never still …

By using light-emitting materials of Venetian smalti, Ravenna glass and white gold, answers are captured and released at one

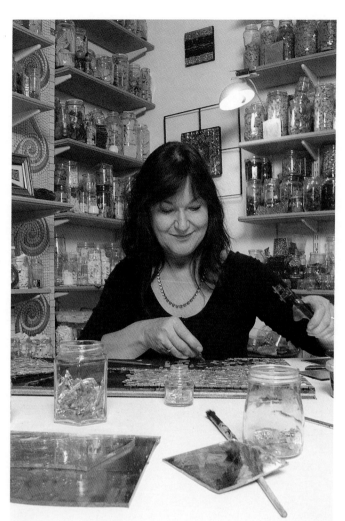

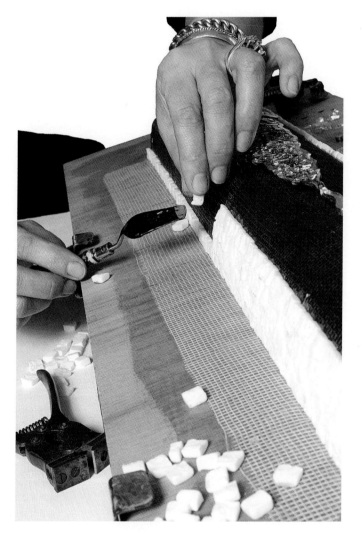

ABOVE: **Building up the curved form with cubes of marble tesserae.**

ABOVE RIGHT: **The artist in the studio.**

RIGHT: **Working on SHE with HE in the background.**

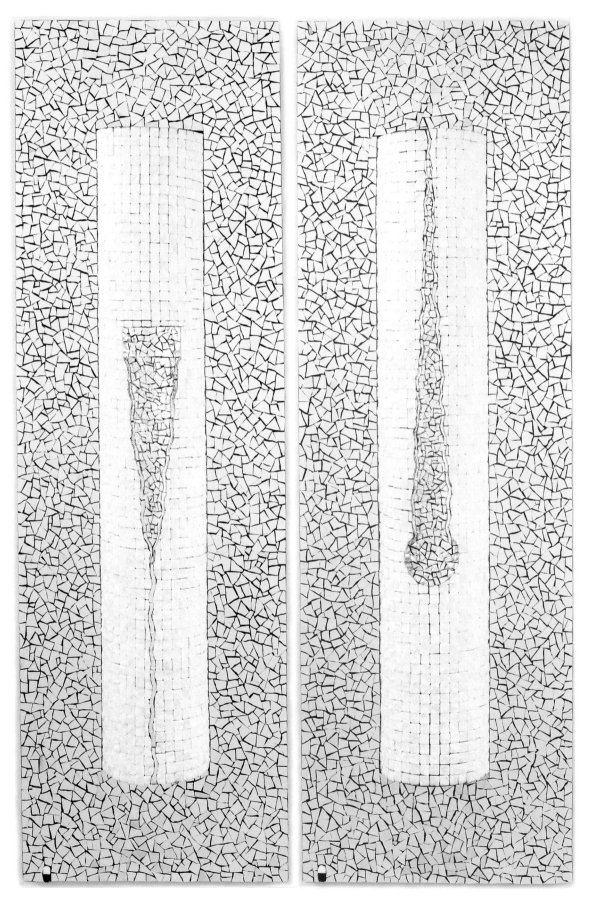

SHE, 2007, 92 × 30cm (36 × 12in), and HE, 92 × 30cm (36 × 12in), Carrara marble, Venetian white metallic gold, Ravennese mirror glass.

The artist with the work in the gallery, Briare, France.

BELOW RIGHT: The working drawing indicating areas of possible colour and direction. Photo: Toyoharu Kii

and the same time. In these two new works, in which a three-dimensional aspect has been introduced, the lit area is both elevated in some lights and recedes in another light, adding to the ambiguity and exchange between the sexes.

Toyoharu Kii (Tokyo, Japan)

Artist's Statement

My process: direct, indirect, direct! The outline of the figure is made up on the vinyl sheet using a direct method. It is then turned upside down, attached to the vinyl sheet with paper clay. Paper clay also fills the spaces between the paper and tesserae. The remaining background is made using the indirect method. Once finished, all the mosaic tesserae are covered with a cement mortar. This is then turned upside down again and the surface of mosaic washed; the work is complete.

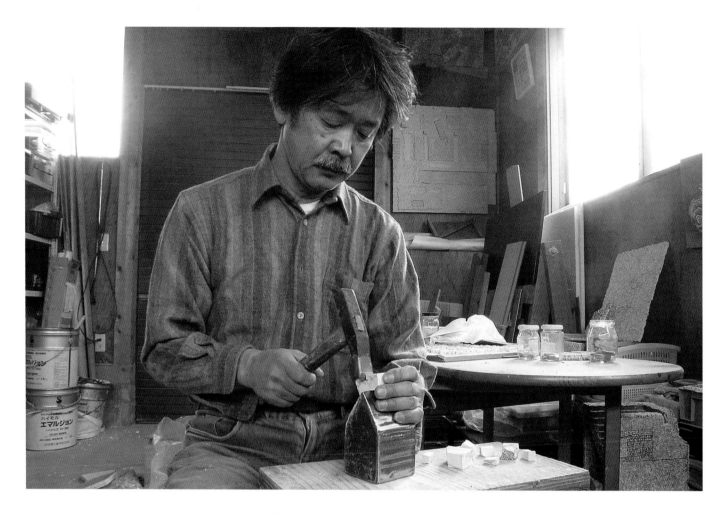

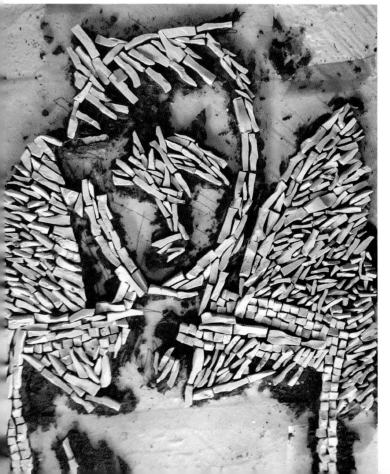

ABOVE: Cutting marble with the hammer and hardie. Photo: Toyoharu Kii

LEFT: The outlined image is created using the direct method. Photo: Toyoharu Kii

BELOW: The artist in the studio, working on the reverse of the image for the background using the indirect method. Photo: Toyoharu Kii

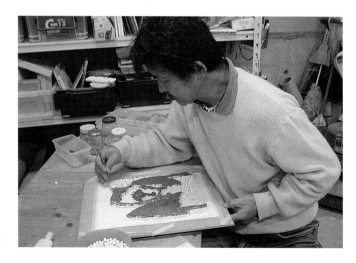

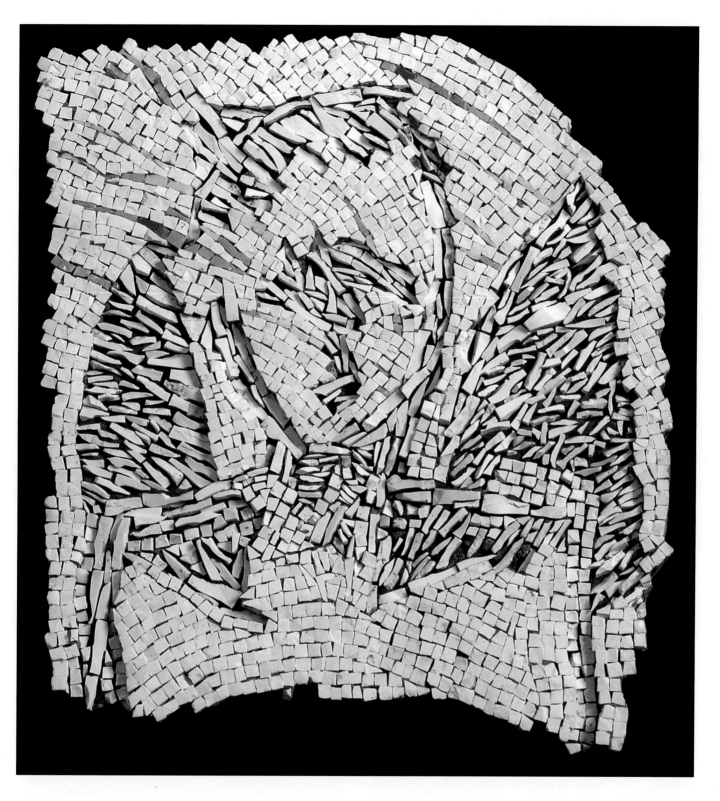

A DREAM OF TESSERAE: A MEMORY OF A WINGED MAN, 2007, 27 × 30cm (10¹/₂ × 12in), marble and smalti. Photo: Studio Saito

The artist and his model.
Photo: Roberta Maioli

Marco de Luca (Ravenna, Italy)

Artist's Statement

The tesserae were laid strictly according to the traditional 'Ravenna method'. The mortar was applied to a wooden support and the work therefore constructed in an internal setting. The cutting of the tesserae was completed before beginning the laying.

This method of directly placing the tesserae in the mortar is definitive, dictated by how much can be done in one day, just like painting a fresco. In working in this way, it was very important to estimate and organize beforehand the appropriate amount of tesserae to be used. The size of the tesserae is therefore in close rapport with both the image to be made and the work as a whole. The method of placing the tesserae at different angles gives the work a variable and diverse surface, allowing the light to refract with each and every part.

BELOW LEFT: **Using a trowel and palette knife to create a good base. Photo: Roberta Maioli**

BELOW: **Pushing the smalti into position in the mortar. Photo: Roberta Maioli**

ABOVE: **The artist at work in the studio. Photo: Roberta Maioli**

RIGHT: PARTICOLARE ANATOMICA, **2007, 70 × 50cm (27¹/₂ × 20in), smalti, gold metallic leaf, marble. Photo: Roberta Maioli**

Dugald MacInnes
(Glasgow, Scotland)

Artist's Statement

My figurative piece is very minimal in approach. It leans heavily on a passion for all things archaeological. Primitive elements have had a lasting impact on my work. It was in a visit a number of years ago to Anatolia, the cradle, perhaps, of our present Western civilization, that I first encountered small stone, clay and bronze figurines. Once the object of status or ritual, they embody the very essence of human spirit; the portrait reduced to essential elements. Piercing eyes, calling to us from a distant past.

ABOVE: **Splitting slate, collected in Scotland for use in the work.**
Photo: Dugald MacInnes

LEFT: **Working on the mosaic, using the cut slate.**
Photo: Dugald MacInnes

BELOW: **Fixing Venetian gold for the inner base panel.**
Photo: Dugald MacInnes

ABOVE: **The artist with the work in the studio.**
Photo: Dugald MacInnes

RIGHT: CHAMBERED TOMB – THE MATED ONES, 2007, 30 × 50cm
(12 × 22in), Scottish slate (Aberfoyle and Easdale), Venetian
gold-leaf. Photo: Dugald MacInnes

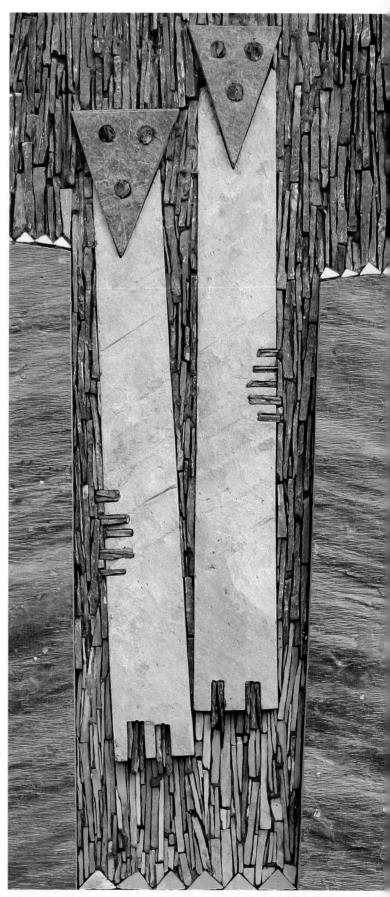

Verdiano Marzi (Paris, France)

Artist's Statement *

This mosaic depicts a woman in the night, a white odalisque. I wanted to express the equilibrium of the female form – fluid, light, sometimes fragile – although some of the materials used produce the opposite effect. The luminosity of the body stands out against the dark, immense, transparent and disquieting background. While the elements comprising the body were assembled according to their original shapes and form with very little intervention on my part, the night sky, in which large, uneven shapes alternate with small, carefully aligned tesserae, is split by flashes of blue. (*Translated by Rosemary Kneipp.*)

* Inspirational verse:

Je suis devant ce paysage feminine

Comme un enfant devant le feu

Souriant vaguement et les larmes aux yeux

Devant ce paysage où tout remue en moi.

'L'extase', Paul Éluard, 24 Novembre 1946

TOP: **Building up the background with slate fragments to complement the round pizze of smalti.**

LEFT: **Continuing building up the background, adding blue marble tesserae.**

BELOW: **Choosing materials for use in the work.**
Photo: Jean-Claude Guilloux

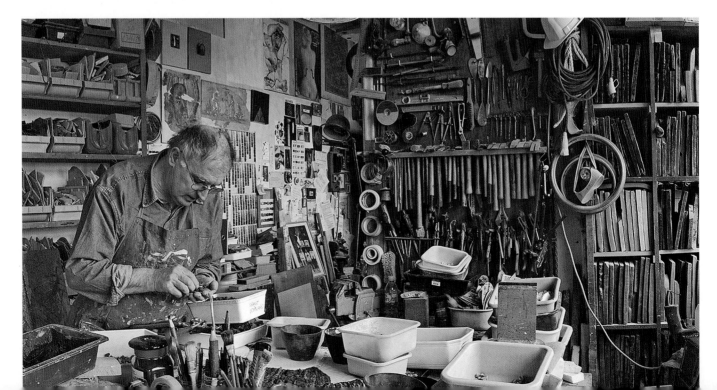

RIGHT: **The artist at work in the studio. Photo: Jean-Claude Guilloux**

BELOW: **NOTTURNO, or ODALISCA BIANCA, 2007, 60 × 91cm (24 × 36in), marble, vitreous glass and granite. Photo: Jean-Claude Guilloux**

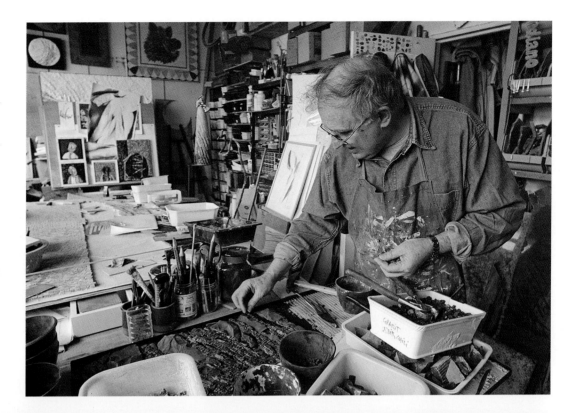

Lucio Orsoni (Venice, Italy)

ABOVE LEFT: **Working drawing – one. Photo: Focal Point**

ABOVE: **Working drawing – two. Photo: Focal Point**

LEFT: **Working drawing – three. Photo: Focal Point**

BELOW: **The artist at work in the studio. Photo: Giulio Candusio**

Artist's Statement

Life drawing of the female figure and *fare mosaico* have always been the main key points in my creative expression. I was challenged by Elaine M. Goodwin's invitation to join her in her new book on human representation in the mosaic medium – it was a fascinating and undoubtedly difficult endeavour to fuse these two antithetical creative expressions.

After various attempts I realized that the only way I could solve this conundrum was to explore the world of sensuality. Thanks to Elaine's request, I discovered that mosaic can transmit subtle sensuality as well.

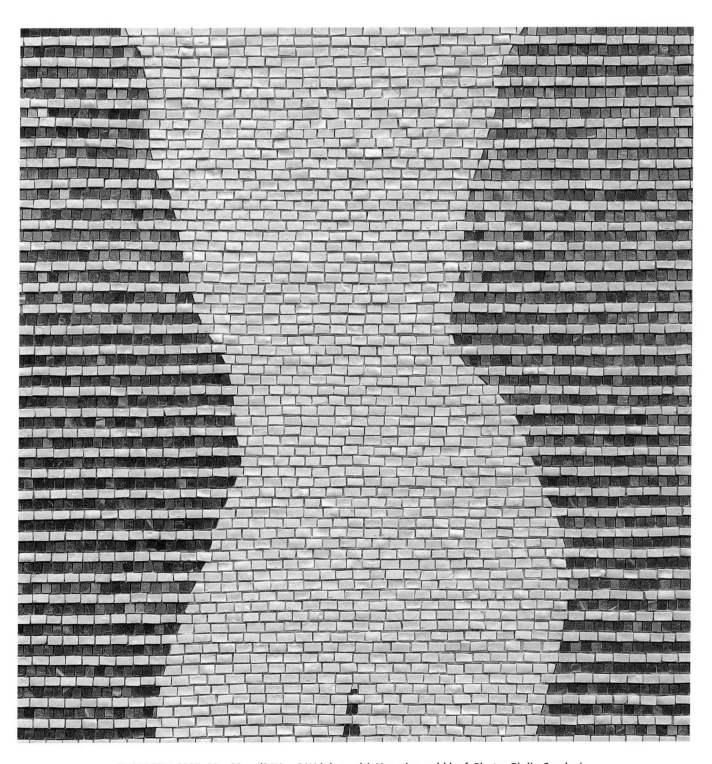

ELISABETH, 2007, 80 × 80cm (31¹/₂ × 31¹/₂in), smalti, Venetian gold leaf. Photo: Giulio Candusio

LEFT: **Preliminary sketch from life. Photo: Ettore Carta**

BELOW LEFT: **The working drawing. Photo: Ettore Carta**

Vanessa Somers Vreeland (Rome, Italy)

Artist's Statement

I am fascinated by the human form. In Paris in the 1970s I painted on canvas, and in transparent plastic, and later in bullet-proof glass. In the 1980s I added mosaics to the mix. Out of this was born my conceit for the figure in mosaic in a transparent medium.

From my original painting I composed the mosaic on a transparent support, being careful to leave a minute space between each tessera. Then the netting was placed on the back of the support, and the liquid plastic was poured on the mosaic. When set, this is polished, giving a prism effect on the sides, if left unframed. The netting, while seeming to anchor the tesserae, actually increases their 'floating' appearance.

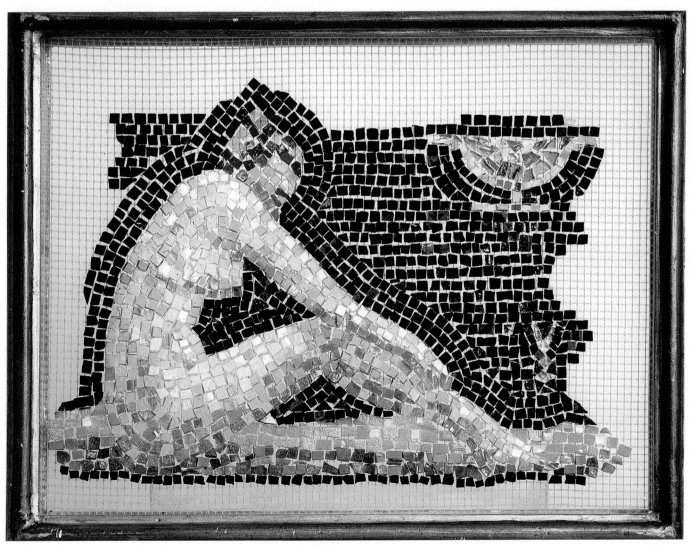

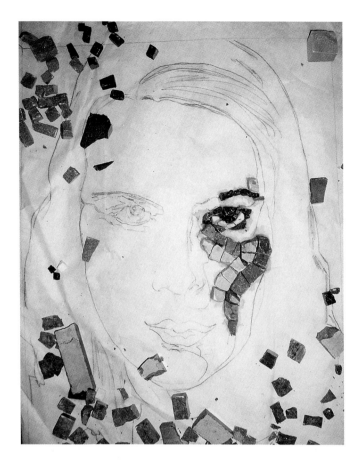

Petar Vujosević (Belgrade, Serbia)

Artist's Statement

For this work, an indirect mosaic technique was utilized. Broken natural rock and stone were fixed to a drawing that had been prepared beforehand. When the mosaic was finished, stucco was poured over it. After a couple of days of drying, the mosaic was turned upside down and the paper with the original drawing was peeled away from the front.

In an enlarged frame, which I use as an extended format, I usually place some additional visual references, which in this case consists of a photo on ribbed cardboard. In this way, I widen the borders of the initial narrative through personal associations.

LEFT: **The working drawing, reversed and the first tesserae applied. Photo: Petar Vujosević**

BELOW LEFT: **Building up the face with tesserae of stone and rock. Photo: Petar Vujosević**

BELOW: **The completed image in reverse. Photo: Petar Vujosević**

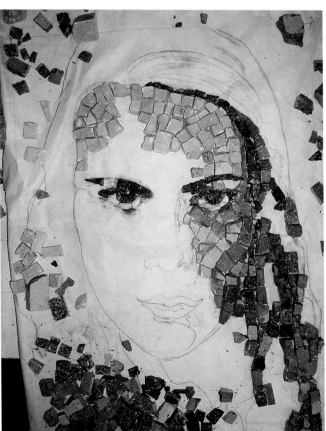

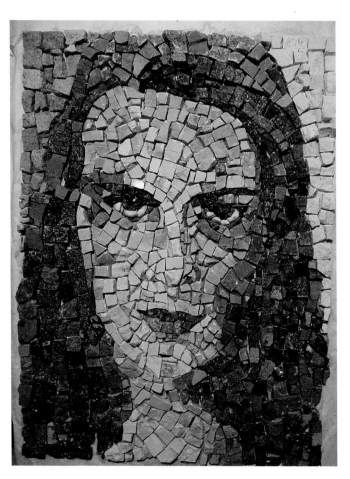

The artist at work in the studio.
Photo: Gordana Stanisić Vujosević

BELOW: BEING, 2006, portrait only, 28 × 40cm (11 × 16in), natural stones. Photo: Petar Vujosević

SHE, Elaine M. Goodwin, Venetian gold, Carrara marble.

ABOUT THE ARTISTS

Robert Field

- Born in Kent, England, 1939. Lives and works in Swanage, Dorset, England.
- Founder Member of BAMM (British Association for Modern Mosaic).
- Member, ASPROM (Association for the Study and Preservation of Roman Mosaics).
- Member, AIEMA (International Association for the Study of Ancient Mosaics).

FROM 1970s
- Teacher in the arts.
- Painter in oils, gouache, acrylic and water colour.
- Author of six books based on geometric patterning.

SINCE 1990
Mosaicist.

RECENT SELECTED EXHIBITIONS
2006 *Ancient Meets Modern*, Cirencester Museum Gallery, England.
2006 Crypt, York Minster, England (BAMM).
2004 Wiltshire Heritage Museum, England (solo).
2004 Salisbury Museum Gallery, England (solo).
2003 *Extravaganza*, Osterley House, London, England (BAMM Open).
2002 *IV Rencontres Internationales de Mosaïque*, Chartres, France.
2001 *Exposure*, Royal Albert Memorial Museum Gallery, Exeter, England (BAMM).
Website: www.robert-field.co.uk

Milun Garćević

- Born in Andrijevica, Croatia, 1959. Lives and works in Zagreb, Croatia.
- Member, AIMC (International Association of Contemporary Mosaicists), Ravenna, Italy.
- Member, AIEMA (International Association for the Study of Ancient Mosaics).
- Member, ICCM (International Committee for the Conservation of Mosaics), Nicosia, Cyprus.
- Member, BAMM (The British Association for Modern Mosaic).
- Restorer of antique and paleo-Christian mosaics.
- Teacher at the Academy of Fine Arts, Zagreb.
- Author of *Mosaic – A Historical Survey, including style and technique*, 2006, Zagreb, Croatia: Ljevak.

RECENT SELECTED EXHIBITIONS
2006 Museum of Contemporary Art, Skopje, Macedonia (AIMC).
2005 Gallery, Hammamet, Tunisia (ICCM).
2005 Gallery, Coimbra, Portugal (AIEMA).
2002 Gallery, Rome, Italy (AIEMA).
2000 Cloister of the Academy of Fine Arts, Ravenna, Italy (AIMC).
1996 L'Atelier of Alexandria, Egypt (AIMC).

Elaine M. Goodwin

- Born in Bedfordshire, England, 1949. Lives and works in Exeter, England and Marrakech, Morocco.
- Director, AIMC (International Association of Contemporary Mosaicists), Ravenna, Italy.
- Founder President, 1999–2005, BAMM (British Association for Modern Mosaic).
- Founder Member of TE[21], Tessellated Expression for the 21st Century – an international exhibiting group for contemporary artists.
- Author of six books on mosaic, including *Encyclopedia of Mosaic*, 2005, London: Batsford.

RECENT SELECTED EXHIBITIONS

2007 *Points de perception*, Gallery of the Musée des Emaux de Briare, France (solo).

2006 *Fênetres sur la perception*, Chapelle St Eman, Chartres, France (solo).

2006 *Musing the Sea*, City Gallery, Southampton, England (solo).

2005 *Aspects of Light II and III*, University of Exeter, England (solo).

2005 *Pulsations de Marrakech*, Dar Cherifa Gallery, Marrakech, Morocco (solo).

2004 *Aspects of Light I*, University of Exeter, England (solo).

2003 *The Muse and the Moselle*, Gallery, British Embassy, Luxembourg (solo).

2002 *Salutations to the Muse*, Gallery, Chateau de Bourglinster, Luxembourg (solo).

Website: www.elainemgoodwin.co.uk

Toyoharu Kii

- Born in Ehime, Japan, 1953. Lives and works in Tokyo, Japan.
- Member, AIMC (International Association of Contemporary Mosaicists), Ravenna, Italy.
- Member of TE[21], Tessellated Expression for the 21st Century – an international exhibiting group for contemporary artists.
- Director of the Mosaic Atelier ING, Tokyo.

RECENT SELECTED EXHIBITIONS

2007 *Mosaic Biennale*, Yokohama Civic Gallery, Azamino, Kanagawa, Japan.

2007 Orie Art Gallery Tokyo, Japan (solo).

2006 Gallery Beaux, Tokyo, Japan (solo).

2005 *Fifth exhibition of the Mosaic Arts Association of Japan*, Fuchu Civic Arts Centre Japan.

2005 Ceramicamosaico, Gallery of Fondazione Casa Oriani, S Maria delle Croci, Ravenna, Italy.

2004 *Seeing the Light*, Collins Gallery, Glasgow, Scotland.

2002 *IV Rencontres Internationales de Mosaïque*, Chartres, France.

Website: www1.ttv.ne.jp/~sosos/index.html

Marco de Luca

- Born in Ravenna, Italy, 1949. Lives and works in Ravenna, Italy.
- Member, AIMC (International Association of Contemporary Mosaicists), Ravenna, Italy.
- Maestro of Mosaic at the Istituto Statale d'Arte for Mosaic in Ravenna, Italy.

RECENT SELECTED EXHIBITIONS

2006 Galleria Arte Studio, Udine, Italy (solo).

2003 *Aquae Lucis*, Galleria Patrizia Poggi, Ravenna, Italy (solo).

2003 *Mosaici di Marco de Luca*, Gallerie, Chapelle St Eman, Chartres, France (solo).

2002 *Ascoltare il Mosaico*, Galleria Arte Studio, Udine, Italy.

2002 *Ascoltare il Mosaico*, Galleria Patrizia Poggi, Ravenna, Italy.

2001 *Opus 5*, Paray-le-Monial, France.

2000 *Giomavepa*, Galerie Crous, Beaux Arts, Paris, France.

2000 *Mosaic: A Living Art – An Anglo-Italian Celebration*, Royal Albert Memorial Museum Gallery, Exeter, England.

Website: www.mosaico.net/marcodeluca

Dugald MacInnes

- Born in Glencoe, Scotland, 1952. Lives and works in Stirling, Scotland.
- Charter Member, SAMA (Society of American Artists).
- Member, BAMM (British Association for Modern Mosaic).
- Founder Member of TE[21], Tessellated Expression for the 21st Century – an international exhibiting group for contemporary artists.

RECENT SELECTED EXHIBITIONS

2007 Spring Mixed Show, Stenton Gallery, Scotland.

2006 Morven Gallery, Isle of Lewis, Scotland.

2006 *Ancient Meets Modern*, Cirencester Museum Gallery, England.

2006 Stenton Gallery, Contemporary Art in Scotland, Edinburgh International Festival, Scotland.

2006 Park Gallery, Falkirk, Scotland (dual with George Garson).

2005 Galerie, Chapelle St Eman, Chartres, France (solo).

2004 *Seeing the Light*, Collins Gallery, Glasgow, Scotland.

2003 Morven Gallery, Isle of Lewis, Scotland (solo).

Website: axisweb.org/artist/dugaldmacinnes

Verdiano Marzi

- Born in Ravenna, Italy, 1949. Lives and works in Bagnolet, Paris, France.
- Co-founder AIMC (International Association of Contemporary Mosaicists), Ravenna, Italy.

- Co-founder, Association Mosaïque Aujourd'hui, Paris, France.
- Publication: *Secrets d'Atelier: Les Mosaïques* with Fabienne Gambrelle, 2005, Paris: Solar.

RECENT SELECTED EXHIBITIONS
2007 *Clair-Obscur*, Viaduc des Arts, Paris, France (solo).
2007 Laboratorio Emme Di, Ravenna Italy (solo).
2005 Joël le Theule Cultural Centre, Sable-sur-Sarthe, France.
2004 Galeria Chapelle St Eman, Chartres, France (solo).
2004 *Seeing the Light*, Collins Gallery, Glasgow, Scotland.
2004 Viaduc des Arts, Paris, France.
2004 Maison d'Art, Strasbourg, France.
2003 *Mosaici sul Po'*, Ca Cornera, Rovigo, Italy (solo).

Website: www.mosaico.net/marzi/index.htm

Lucio Orsoni

- Born in Venice, Italy, 1939. Lives and works in Venice, Italy.
- Great-grandson of Angelo Orsoni, founder of the world-renowned smalti and gold-leaf mosaic firm, Orsoni, Cannaregio, where he has a fundamental creative input. A permanent exhibition of his work can be seen in Cannaregio.
- Member, AIMC (International Association of Contemporary Mosaicists), Ravenna, Italy.
- Member, TE[21], Tessellated Expression for the 21st Century – an international exhibiting group for contemporary artists.

RECENT SELECTED EXHIBITIONS
2006 *Pictor Imagnarius: magister musivarius*, archaeological area, Cathedral of San Stefano, Concordia Saggitaria, Italy.
2004 *Opus Veritas*, San Francisco, USA.
2004 *Seeing the Light*, Collins Gallery, Glasgow, Scotland.
2002 Moscow Art Gallery, Russia (solo).
2000 *Mosaic: A Living Art – An Anglo-Italian Celebration*, Royal Albert Memorial Museum Gallery, Exeter, England.
2000 Ruskin Gallery, Sheffield, England.

Website: www.orsoni.com

Vanessa Somers Vreeland

- Born in London, England. Lives and works in Rome, Italy.

1970s
- Drawing and painting in Paris. Collaborated with the St Gobain glassworks; experimented with plastic and bullet-proof glass.

1980s
- Studied mosaic with Professor Odoardo Anselmi, the Vatican maestro mosaic artist.

2006
- Teacher in mosaic, Penland, North Carolina; Museum of Art, South Carolina and Columbia, USA.

RECENT SELECTED EXHIBITIONS
2006 Artist in Residence, Corning Museum of Glass, New York, USA.
2006 *Eyes*, Galerie Luniverre, Paris, France (solo).
2001 Group Show, Corning Museum, Corning, New York, USA.
2001 Artist in Residence, Glass Studio, Portland, Oregon, USA.
2000 *The Human Body*, Studio S, Rome, Italy.
1998 USIS, Rabat, Morocco (solo).
1997 Artist in Residence, Glass Studio, Portland, Oregon, USA.

Petar Vujosević

- Born in Niksić, Montenegro, 1959. Lives and works in Belgrade, Serbia and Bar, Montenegro.
- Co-founder of the Group Amethyst, established in Belgrade in 2001 to promote universal values of spirituality and art through the medium of mosaic.
- Member of the Fine Art Artists Association, Montenegro (ULUCG).

RECENT SELECTED EXHIBITIONS
2007 *Point of View* (the concrete and abstract in mosaic), Belgrade, Serbia (with Amethyst).
2006 *Harmony of the Contemporary, Antique and Early Byzantine Mosaic*, Smederevo (with Amethyst).
2006 Recent mosaics, Belgrade, Serbia (with Amethyst).
2005 *Epigraph* (four spaces of the early Christian cosmos), Belgrade, Serbia (with Amethyst).
2004 Contemporary Mosaic Gallery: Sombor, Centre of Culture, Laza Kostić, Belgrade, Serbia.
2003 Contemporary Mosaic Gallery, Sombor, Centre of Culture, Vrbas.
2003 *Homage to Aleksanda Tomasević*, Library of the city of Belgrade, Serbia.
2003 *The Harmony of Contemporary, Antique and Early Byzantine Mosaics*, Bitolj, National Museum.

Website: www.ametist-mozaik.org

THE PROFANE HUMAN FORM

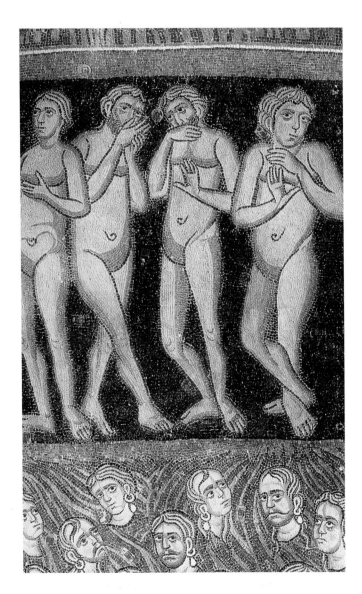

An aspect of the human figure in mosaic which is impossible to celebrate but which I want briefly to mention, is when the unclothed form is used in a profane way – when the body is not considered one of divine perfection and sheer delight but as an outward show of shame and humiliation.

In the Christian mediaeval period, artists, having adhered to the Second Commandment of the Old Testament in not creating any graven images, began again to look at the naked human form. Themes of the Last Judgement allowed full rein to the imagination in depicting the human form in varying degrees of depravity.

A fine example of a Last Judgement in mosaic can be viewed in the Basilica of Santa Maria Assunta, on the island of Torcello, Venice, Italy. The deadly sins are strikingly depicted in memorable human forms, for example the gluttonous are shown eating their own hands, while the wealthy, of all races, are shown as decapitated portraits, their heads still jewel-encrusted but surrounded by fierce flames.

Examples in the first part of the twentieth century where mosaic was used to create a shocking, permanent testament to the depravity that one human can inflict upon another can be seen in the black and white murals created in a Nazi transit camp in Serbia. Here, the bodies, in the stylized manner of the period, are raw with naked energy and pathos, and become concrete mementoes to universal shame, recorded for posterity in simple black and white marble tiles. To me, they recall Picasso's *Guernica*, painted in a similarly stark and terrifying manner.

ABOVE: LAST JUDGEMENT, **detail, Santa Maria Assunta, twelfth/thirteenth century, Torcello, Venice, Italy. Photo: Elaine M. Goodwin**

RIGHT: **Mosaic mural, Serbian Nazi transit camp, 1920s. Photo: Chris Noble**

SUGGESTED FURTHER VIEWING

It is more than likely that in making figurative mosaics or in scrutinizing mosaic figures from history for inspiration, you will want to seek out further examples of work to study and enjoy. The list below is by no means comprehensive, but is a personally collated list of superb examples of figurative mosaics or occasional other works, easily seen either in situ or as a result of being lifted and placed in a museum or gallery – repositories which often allow close-up viewing.

I have listed them to correspond with each project area of the book.

Introduction

This beautiful rendering of the female form, with her back towards the viewer, is composed of simply modulated tesserae in a superbly controlled grading of colours, terracotta, ochre and pale stone.

It is one of a great many female figures, or nymphs, those minor divinities of nature, that the Romans delighted in depicting. They appear with great frequency, naked or semi-clad, as part of larger decorative schemes in the villas of the Roman Empire.

The Foro Italica, formerly known as the Foro Mussolini, is a vast mosaic-encrusted stadium and sports arena. The mosaics were designed by eminent artists including Gino Severini, Angelo Canevari, Giulio Rosso and Achille Capizzano, and are of startling quality and vivacity.

The mosaics were executed by the renowned Scuola del Mosaico in Spilimbergo, Friuli, Italy, between 1933–37. The figures were realized in marble in two ways: as simple black silhouetted forms on a white ground with internal single line articulation, recalling those at Ostia Antica; or, as here in the swimming pool, in highly sophisticated polychrome figures of naturalistic rendering.

ABOVE: ATHLETES, **detail, 1933–37, Piscina Olimpionica, Foro Italica, Rome, Italy, by Angelo Canevari (1901–55), designer of the polychrome mosaics, and Giulio Rosso, designer of the black and white mosaics. Photo: Elaine M. Goodwin**

LEFT: A BATHING NYMPH, **detail, fourth century CE, from a** *cubiculum* **(bedroom), Archaeological Museum of Nabeul (Neapolis), Tunisia. Photo: Elaine M. Goodwin**

Project One – The Lion-Hunter

Mosaics

This floor mosaic is a highly complex figurative composition with an advanced perspective and superb figure rendering. The modelling of the bodies is conveyed with masterly manipulation of light-coloured pebbles to give an extraordinarily accomplished and sensitive plasticity. The sense of space within the work is enhanced by the inclusion of a hunting dog, appearing at the lower left-hand side of the mosaic. It leaps into the picture at an oblique angle, leading the viewer in and exaggerating the spatial depth.

Gnosis is the oldest mosaicist recorded in the medium's historic pantheon and is justifiably greatly revered.

- *Frenzied Female Nymphs*, pebble mosaic, fifth century BCE, Olynthos, northern Greece.
- *Tiger Hunt*, the Great Palace, fourth century CE, Mosaic Museum, Istanbul, Turkey.

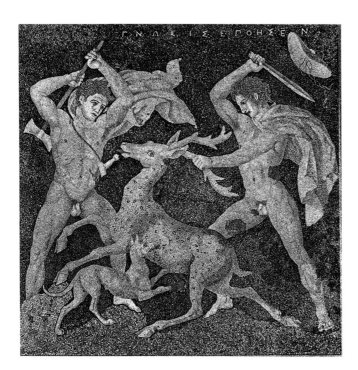

ABOVE: **STAG HUNT, fourth century** BCE; **pebble mosaic by Gnosis, Archaeological Museum, Pella, Macedonia, Greece.**
Photo: Elaine M. Goodwin

RIGHT: **THE JUDGEMENT OF PARIS, detail, by Lucas Cranach the Elder (1472–1553), Staatliche Kunsthalle, Karlsruhe, Germany.**
Photo: Elaine M. Goodwin

Sculpture

- *Poseidon*, sculpture, c.460BCE, bronze, 2.08m (6ft 10in), National Museum, Athens, Greece.
- *Greeks and Amazons*, relief sculpture, c.350BCE, from the frieze of Mausoleum, British Museum, London, England.
- *Borghese Warrior* (so-called) – sculpture, third century BCE, Louvre, Paris, France.

Drawing and Engraving

- Antonio Pallaiuolo, c.1432–98, *Hercules*, c.1460, British Museum, London, England.
- Antonio Pallaiuolo, *Battle of Nude Men*, c.1470, British Museum, London, England.

Projects Two and Three – The Three Graces

Paintings

Lucas Cranach developed a new form for the female nude figure, possibly inspired by viewing influences from the great Florentine painter, Sandro Botticelli.

In this work, recalling the pose of the Three Graces, a trio of female nude figures, Athena, Aphrodite and Hera (as they were known in Roman mythology), delight and taunt the viewer today as much as in Cranach's era. The sinuous forms, seen here for clarity in black and white, artfully capture the imagination of the viewer as they pose naked except for outsized headwear and giant necklaces. The undulating outline of their forms, with narrow shoulders and gently swelling stomachs, created a new and very anti-Classical mien.

- *The Three Graces* by Sandro Botticelli (1445–1510), Uffizi Gallery, Florence, Italy.
- *The Three Graces* by Raphael (1483–1520), Musée Condé, Chantilly, France.
- *The Three Graces* by Peter-Paul Rubens (1577–1640), The Prado, Madrid, Spain.

Sculpture

- Graeco-Roman, *The Three Graces*, Siena, Italy.
- *The Three Graces* by Aristide Maillol (1861–1944), Tate Gallery, London, England.

RIGHT: A NYMPH, detail from THE HOUSE OF VENUS, Volubilis, Morocco, third century CE. Photo: Elaine M. Goodwin

BELOW: AMPHITRITE, detail, before 79CE. Courtyard of the House of Neptune, Herculaneum, Italy. Photo: Elaine M. Goodwin

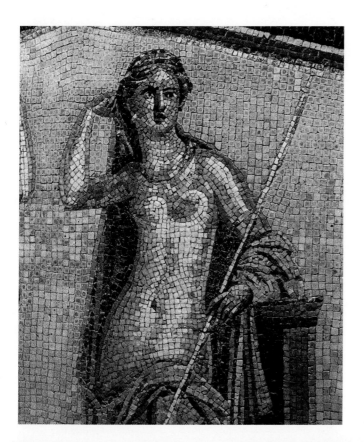

Mosaics

The goddess Amphitrite was the consort of Neptune, ruler of the sea, who appears at her side in this wonderful mosaic on a wall in an external inner courtyard. The tessellation of the form is stunningly simple. It is composed of quite large tesserae modulated in a concise and economical way, giving weight to the movement across the form as much as in the vertical contouring.

The confident handling of the tesserae marks it out as a masterpiece of early mosaic work in Italy, combining Hellenic influence with Roman sensibility of the medium.

- *Europa and the Bull*, Archaeological Museum, Aquileia, Italy, first century CE.
- *Europa and the Bull*, Lullingstone Roman Villa, Kent, England, fourth century CE.

Projects Four and Five – Venus

Mosaics

This is a detail from a beautiful mosaic depicting the young Hylas surrounded by the nymphs or naiads of the fountain, who tempt the god to stay with them at the water source.

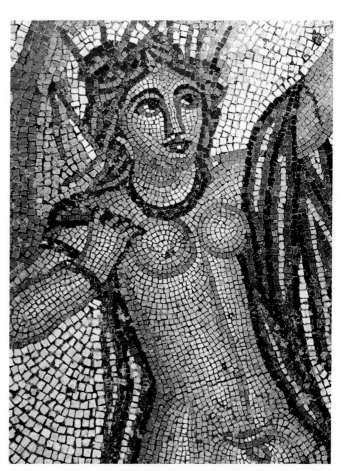

The form of the nymph is elegantly and simply tessellated, with complete circles of tesserae for the breasts and a complementary balance of circular forms for the stomach area. The figure is in softly graded tones of regular cube-shaped tesserae and is set to advantage against a darker mantle, a device used with great frequency in mosaics of this nature, where the darker form helps to separate the light-coloured torso from a white or pale background. Note the single line of tesserae surrounding most of the form, before the background continues in a loose opus *tessellatum*.

- The Rudston Venus, 300–400CE, Museum of Kingston-upon-Hull, North Humberside, England.

Project Six – The First Man

Mosaics

- Church of Santa Maria dell'Ammiraglio (la Martorana), 1140, Palermo, Sicily, Italy.
- Palatine Chapel, 1150–60, Palermo, Sicily, Italy.
- Cathedral of Monreale, 1174–82, Sicily, Italy.
- Cefalù cathedral, 1148, Sicily, Italy.
- *La Zisa*, Royal Villa, 1190, outside Palermo, Sicily, Italy (a secular work).
- Room of King Ruggero in the tower of the Sacred Palace, twelfth century, Palermo, Sicily, Italy.

RIGHT: **Architectural feature (spandrel), early eighth century CE, the Great Mosque of Damascus, Syria.**
Photo: Elaine M. Goodwin

BELOW: **ADAM AND EVE, detail, from the creation theme, *c.*1220, Cathedral of San Marco, Venice, Italy.**
Photo: Elaine M. Goodwin

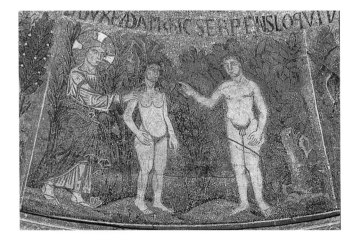

The creation cupola is one of a trio of shallow domes in the narthex of the great cathedral. It is composed of three concentric circles. The outer circular frieze depicts the creation of Adam and Eve in a number of stages up to their expulsion from the Garden of Eden. The figures are outlined strongly in lines of red smalti and are set against a luscious green foliate background.

The bodies of Adam and Eve are rather heavy and thickset, so unlike the elongated figures in the creation schemes in Sicily, and show Northern European painterly borrowings. The internal linear modelling is composed of bands of flesh-coloured smalti with ellipsoidal shapes lightly introduced at the thighs, stomach area, shoulders and knees.

- Dome of the Rock, *c.*690CE, Jerusalem, Israel.
- The Great Mosque, *c.*715CE, Damascus, Syria.
- The Mihrab, *c.*970CE, Great Mosque of Cordoba, Spain.

This ornamental detail is found inside the west portico of the courtyard, where a number of mosaics showing architectural details are to be found.

The mosaic features gold and silver Venetian gold and smalti of greens, blues and reds. Delightfully, the mosaic also has tesserae made of mother-of-pearl (a material found even today in furniture and trinket box inlays in Syria). This material is used to great effect in the mosaic, in the curtaining of architectural doorways, where hanging chains of smalti terminate in shaped jewels of nacreous mother-of-pearl. These beaded curtains can also be seen in Middle Eastern doorways nowadays, being both beautiful and efficient in filtering out the glaring sunlight.

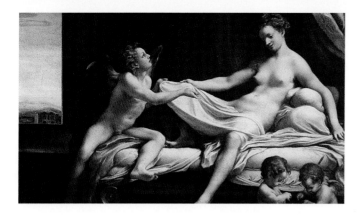

ABOVE: DANAË AND THE SHOWER OF GOLD, **by Correggio (1489–1534), Borghese Gallery, Rome, Italy.** Photo: Elaine M. Goodwin

RIGHT: DANAË **by Gustav Klimt (1862–1918), 1907, private collection, Graz, Austria.**

Project Seven – Self-Portrait

Fresco and Encaustic works

- *Portrait of a Young Woman with Stylus*, Pompeiian wall painting (before 79CE) Museo Nazionale Naples, Italy.
- *Mummy Portrait of a Man*, coloured wax on wood, height 40cm (16in), British Museum, London, England.

Paintings

Correggio is a master of the dramatic in terms of light and shade. His works are vibrant with light, often from many sources. His figures of women are sensuous and rejoice in their feminine charms.

This rendering of Danaë allows a bright and silvery light to ripple delicately all over her body. The playful nature of the work is summed up in the gentle smile on her face. Zeus and his shower of gold, delights!

- *Danaë* by Titian (*c.*1485–1576), *c.*1546–7, Prado, Madrid, Spain.
- *Danaë* by Titian, *c.*1560, Kunsthistorisches Museum, Vienna, Austria.
- *Venus of Urbino* by Titian, 1538, Uffizi, Florence, Italy.
- *Reclining Venus* by Giorgione (*c.*1477–1510), *c.*1506, Dresden, Germany.
- *Nymph* by Lucas Cranach the Elder (1472–1533), *c.*1530, Thyssen-Bornermisza Collection, Switzerland.
- *Blue Nude (Souvenir of Biskra)* by Henri Matisse (1869–1954), 1906, Baltimore Museum of Art, USA.
- *Olympia* by Edouard Manet (1832–83), 1863, Musée du Jeu du Paume, Paris, France.

Klimt's female nudes are at once erotic and ornamental. In this portrayal of Danaë, the bronze chamber which holds her captive becomes a dark ground on which to decorate both the delicate textiles depicted and a receptive female form.

Klimt's visit to Ravenna in 1903 and the church of San Vitale in particular, inspired a series of works in which he combined paint with mosaic materials, especially Venetian metallic gold. The graphically drawn picture of the female with its enlarged thigh area would translate well into a mosaic. The famed School of Mosaic at Spilimbergo in Northern Italy regularly endorses students in the making of facsimiles of Klimt's work.

Project Eight – Rama

Mosaics

This is the second of two mosaic portraits of professional athletes discovered at the site of the terme or baths in Aquileia, northeastern Italy. The bathhouse floor from which they were excavated would have been patronized by the athletics themselves and their portraits would have been revered in the same manner as a wall of photographs depicting Hollywood 'greats'.

This bearded athlete, older than the one featured in Project Eight, is again superbly tessellated with a consummate authority. Note, in particular, where the tessellation of the right cheek encounters that of the beard, with a skilful and deliberate change of articulation.

- *Female Athletes*, Villa Romana, Piazza Armerina, Casale, Sicily, Italy, *c.* fourth–fifth century CE.
- Foro Italica, 1933–37, Rome, Italy: gymnasts and athletes, polychrome wall murals and monochrome black on white floor mosaics.

This detail of two nude runners, professional athletes, is from a larger work depicting sporting contests and competitors such as boxers and wrestlers. The size of the tesserae used in the bodies is equal to that used in the background, confirming it was made in situ. The figures are outlined in tesserae of burnt sienna and dark terracotta. The internal modelling is simply but confidently built up by using mainly cube-shaped tesserae, to define the muscles of the chest and stomach area – torsos toned by athletic practice and prowess!

- *Athletes*, Terme Marittime, Ostia, Italy, third century CE.
- *Athletes*, Terme di Nettuno, Ostia, Italy, second century CE.
- *Athletes*, Terme di Caracalla, Rome, Italy, early third century CE.
- *Prize Wrestlers*, Bathhouse, Thyna (Thaenae), Sfax Museum, Tunisia, third century CE.
- *Athlete*, third century CE portrait of the famed athlete, Nikostratos, found at the House of the Porticoes, Seleucia Pieria, Hatay Archaeological Museum, Antioch, Turkey.

Project Nine – Bethany

Mosaics

The great and wondrous edifice of Hagia Sophia houses many mosaics from many periods of time, each mosaic reflecting the changing artistic tastes of their period.

This richly executed mosaic shows the Empress Irene, clothed in a highly patterned robe, resplendent with tessera of red, green, gold and mother-of-pearl set on a luscious golden ground. There is a bejewelled crown on her head. Her face appears, strangely, as a mask – her glance is to the side, not with the frontal gaze most often associated with hierarchical Byzantine

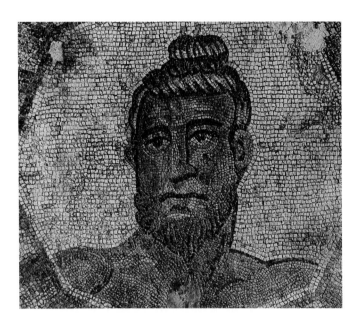

ABOVE: HEAD OF AN ATHLETE, **third century CE, detail, Terme, Aquileia Archaeological Museum, Italy.**
Photo: Elaine M. Goodwin

RIGHT: EMPRESS IRENE, **twelfth century CE, south gallery, Hagia Sophia, Istanbul, Turkey. Photo: Elaine M. Goodwin**

BELOW: TWO ATHLETES, **detail, fourth century CE, Batten Zamour, Archaeological Museum, Gafsa (Capsa), Tunisia.**
Photo: Elaine M. Goodwin

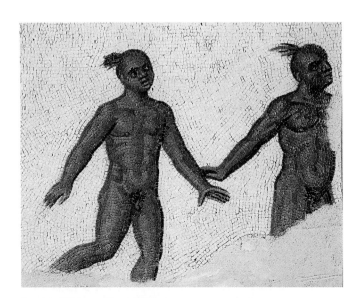

figures.* The tesserae are very small indeed and composed in a rhythmically linear manner, with a strong red colour in the cheek area. It is as if humanity is suppressed when robed in the weighty splendour of an acknowledged Byzantine hierarchy.

- *Empress Zoë*, eleventh century, south gallery, Hagia Sophia, Istanbul, Turkey.
- S Appollinare in Classe, *c.*550CE, Ravenna, Italy.
- S Appollinare Nuovo, early sixth century CE, Ravenna, Italy.
- *Angel*, late fourth–early fifth century CE, chapel of S Zenone, S Prassede, Rome, Italy.
- Sa Maria in Domnica, *c.*820CE, Rome, Italy.
- SS Nerone e Achilleo, *c.*800CE, Rome, Italy.
- SS Cosma e Damiano, *c.*530CE, Rome, Italy.
- SS Prassede, *c.*820CE, Rome, Italy.
- Sa Cecilia, *c.*820CE, Rome, Italy.
- St Germigny de Près, *c.* ninth century CE, France.
- S Demetrios, *c.*630CE, Hagios Dimitrios, Thessaloniki, Greece.
- Hagios Georgios, *c.* fourth–fifth century CE, Thessaloniki, Greece.

Project Ten – Darius

Mosaics

Sir Edward Burne-Jones (1833–98) was a painter often associated with the Pre-Raphaelite Brotherhood. His palette was rich in colour and his figures often elongated and idealized. This grouped procession was the first mosaic commission undertaken by the artist, and is composed in resonant colours, including pinks, purple, blues and greens. The mosaics are made of smalti and set in quite a regular way, as was to be the style of the period. They were made from Burne-Jones's cartoons by the Venezia-Murano Mosaic Company. The outlines of the hands and faces are strongly defined and shaded in an andamento of pinks and mid-flesh tints.

RIGHT: APSE MURAL, **detail, 1907, designed by Edward Burne-Jones, executed after his death by his assistant, Thomas Matthew Rooke; the American Protestant Episcopal church of St Paul's within the Walls, Via Nazionale, Rome, Italy. Photo: Elaine M. Goodwin**

* It is possible that this is a 'second face', replacing the original, which may well have been a former empress.

This last of a series of completed designs for the church of St Paul's is generally titled *The Early Paradise, the Church Triumphant*. The group of martyred Virgin Saints, each with her identifying attributes, files down from the hills. Many of the figures are known to be contemporary portraits, including the artist's wife, Georgiana, Lady Burne-Jones (1840–1920), as St Barbara (with the tower).

- Church of St Mary and St Nicholas, 1908–20 (Lady Chapel 1946), Wilton, Wiltshire, England, apse mosaic designed by Sir Charles Nicholson (executed by Gertrude Martin, *c.*1865–*c.*1946).
- *The Embrace* (1905–09) by Gustav Klimt, Österreichisches Museum, Vienna.
- Sanctuary mosaics designed by F. Hamilton Jackson, 1911, St Bartholomew's, Brighton, England (executed by an Italian firm).
- Basilica mosaics, designed 1922–32 by Gabriel Pippet, the Church of the Sacred Heart and St Catherine, Droitwich, England (executed by Maurice and Thomas Josey and Fred Oates).
- Church of St John the Baptist, 1931–33, Manchester, England, sanctuary mosaics designed by Eric Newton (executed by his father, Ludwig Oppenheimer, of L. Oppenheimer Ltd).
- *St John the Baptist*, Paris, mosaic mural by Jean Gaudin, 1935.

SELECTED BIBLIOGRAPHY

Andronicos, Manolis (1979), *Pella Museum*, Athens: Ekdotike Athenon SA.

Avery, Catherine B. (ed.) (1962), *The New Century Classical Handbook*, London: Harrap.

Barrucand, M. and A. Bednorz (1992), *Moorish Architecture in Andalusia*, Cologne: Taschen.

Bertelli, Carlo (1988), *Il Mosaico*, Milan: Mondadori Editore.

Bovini, G. and M. Pierpaoli (1991), *Ravenna, Treasures of Light*, Ravenna: Longo-Editore (rev. edn 2002).

Carr-Gomm, Sarah (2000), *Dictionary of Symbolism in Art*, London: Duncan Baird Publishers.

Chatzidakis, M. and A. Grabar (1964), *Byzantine and Early Mediaeval Painting*, London: Weidenfeld and Nicolson.

Chierichetti, Sandro (1960), *Ravenna, an illustrated guide*, Ravenna: Ed Fratelli Leonardi.

Clark, John R. (1979), *Roman Black and White Figural Mosaics*, New York: New York University Press.

Clarke, Kenneth (1956), *The Nude*, London: Pelican Books.

Demus, Otto (1948), *Byzantine Mosaic Decoration*, London: Kegan Paul.

Devambez, Pierre (1962), *Greek Painting*, London: Weidenfeld and Nicolson.

Ettinghausen, Richard (1977), *Arab Painting*, New York: Rizzoli International.

Feder, Theodore H. (1978), *Great Treasures of Pompeii and Herculaneum*, New York: Abbeville Press.

Fiorentini Roncuzzi, Isotta and Elisabetta Fiorentini (2002), *Mosaic: Materials, Techniques and History*, Ravenna: MW EV Editions.

Gibellini, Cecilia (ed.) (2006), *Titian*, preface by Corrado Cagli, New York: Rizzoli International.

Goodwin, Elaine M. (2003), *Encyclopedia of Mosaic*, London: Batsford/Chrysalis.

Hall's Dictionary of Subjects and Symbols in Art (1974), London: John Murray.

Jobst, W., B. Erdal and C. Gurtner (1997), *Istanbul, The Great Palace Mosaic*, Istanbul: Arkeolojive Sanat Publications.

Johnson, Peter (1982), *Romano-British Mosaics*, Buckinghamshire: Shire Publications.

L'Orange, H. P. and J. Nordhagen (1966), *Mosaics*, London: Methuen.

Lucie-Smith, Edward (2004), *Ars Erotica*, Royston, Herts: Eagle Editions Ltd.

Marcuzzi, Luigi (1993), *Aquileia*, pub. Società per la Conservazione della Basilica di Aquileia, Italy.

Martindale, Andrew (1966), *Man and the Renaissance*, London: Paul Hamlyn.

Mosaic: A Living Art, an Anglo-Italian Celebration, 2000, curator Elaine M. Goodwin; exhibition catalogue ISBN 1-85522-749-5.

Neuman, Heinrich (1963), *Byzantine Mosaics*, Vienna: Verlag Brüder.

Pella and its Environs (2004), Ministry of Macedonia –Thracian Culture, Greece.

Powell, Ann (1973), *The Origins of Western Art*, London: Arts Book Club.

Reed, Herbert (1965), *The Styles of European Art*, London: Thames and Hudson.

Reynolds, Simon (1994), *A Companion to the Mosaics of St Paul's Cathedral*, London: Michael Russell Publishing Ltd.

Rice Millon, Judith (1982), *St Paul's Within the Walls*, New Hampshire, USA: William L. Bauhan.

Roiter, Fulvio (1994), *Aquileia /Ravenna*, Treviso: Vianello Libri e Credito Romagnelo.

Rossi, Ferdinando (1970), *Mosaics: A Survey of their History and Techniques*, London: Pall Mall Press.

Saunders, Gill (1989), *The Nude, a New Perspective*, London: the Herbert Press.

Schirò, Guiseppe (1996), *Monreale, City of the Golden Temple*, Palermo: G. Mistretta.

Smith, B. J. (1987), *Roman Mosaics at Hull*, City of Hull, Museum and Art Galleries.

Stone, Denis E. (1965), *The Classical World*, London: Paul Hamlyn.

Sutton, Denys (1963), *Titian*, New York: Barnes and Noble.

Taşkiran, Celâl (1994), *Silifke and Environs*, Ankara.

Webb, Peter (1979), *The Erotic Arts*, London: the Leisure Circle.

SUMMARY OF MATERIALS AND TOOLS AND THEIR USAGE

I have endeavoured for this publication to use the simplest of materials, which are easily accessible to all who would wish to create figurative mosaics for themselves.

For the Drawing

The drawings for each project were drawn directly onto a backing board, using everyday and commonplace materials – soft pencils, 3B and 4B, and hard pencils, HB; charcoal pencils; and felt-tipped pens – fine, pointed and chisel-ended. The methods of transferring a drawing or photographic image can be as below:

By eye: the method I use most, which gives a natural and spontaneous result, with unique idiosyncrasies!

By squaring up: a popular method to transfer a very small photograph or picture onto a much larger backing board. Use the same ratio, for example 2cm = 10cm (1in = 4in), or whatever is appropriate, throughout the procedure. Square up the photograph or picture, by forming a grid of squares on the image, and redraw the image square by square onto a backing board, which has a proportionate grid of squares pre-drawn on it. When completed, strengthen the drawing by eye, using a felt-tipped pen.

By transfer: use transfer or greaseproof paper to create a drawing of identical size to that being copied. Draw over the image using a hard pencil. Place a sheet of carbon paper or similar and redraw over the transfer drawing. Strengthen this image also by eye, with a felt-tipped pen.

By photocopying: photocopy a drawing, picture or photograph, adjusting the size to suit the backing timber. Place carbon paper between the backing board and the photocopy, and draw over the photocopied image, using a hard pencil. Strengthen the drawing on the backing board by eye, with a felt-tipped pen.

The Backing Board

Each mosaic was made using a timber base. Plywood is an easily obtained timber and can be cut to any size from a 2.44m × 1.22m (8ft × 4ft) sheet. It provides an excellent backing timber for mosaic work. It comes in three different main categories. Interior quality – suitable for small, internally positioned works; exterior quality – fine for mosaics of greater size and displayed internally; and marine ply – an extremely durable (and much more expensive) resinated timber, heavier to lift and suitable for very large works and those placed in protected exterior positions and also bathrooms and kitchens. All timber is weakened in damp conditions: in plywood it is the cut edges that are the most vulnerable and need sealing. Most of the works created for the projects have been edged with a proprietary waterproof sealer that is suitable for adhering to timber. This can be found in a variety of colours and dark grey or black.

Adhesives

All the work in the projects uses the *direct* method, a technique which applies the cut material directly onto a backing board. Timber is a porous material and most materials, whether porous (ceramic, stone, marble) or non-porous (glass, metallic gold), will adhere to it using a PVA (polyvinyl acetate) glue, sometimes termed white glue. There are a number of such adhesives on the market; choose a reputable one which dries colourless, as this stops any visual interference with coloured material being used in the mosaic making. The adhesive is usually applied using a palette knife. Put a little onto the back of each tessera, before securing it in position. It dries very strongly over twenty-four hours, needing a chisel and hammer to be removed.

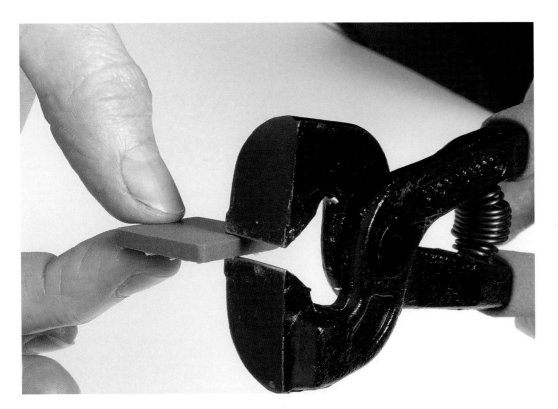

DEMONSTRATIONS
SHOWING THE VARIOUS
CUTTING TOOLS AND
SUGGESTED USAGE (I)

LEFT: **Use heavy duty or standard mosaic nippers to cut unglazed ceramic and porcelain mosaic tiles.**

MIDDLE: **Use standard wheeled mosaic nippers to cut smalti horizontally or longitudinally.**

BOTTOM: **Use sprung double-action nippers to cut glazed ceramic mosaic tiles.**

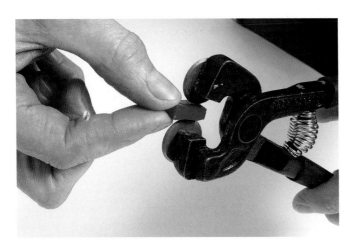

Tools

The tools used to cut the materials for all the projects fall into two categories:

The hammer and hardie: the hardie is derived from an ancient chiselled cutting tool. It is generally fixed into a block or trunk of wood, which is normally placed at chair height and can be comfortably positioned between the knees for cutting on. The cutting action is one from above, directly onto a tessera of marble or smalto using a mosaic hammer. The cut edge strikes the tessera placed on the chisel edge in half. Practise with care and confidence.

Handheld mosaic nippers: there is a great variety, all with one thing in common – the spring. This allows for easy usage, as the mouth, or cutting edges of the nipper, are always open. Styles include: regular long handled; heavy duty long handled; and wheeled. A variety of types are demonstrated in this publication. In each case, the tessera is inserted between the cutting edges, but only fractionally, and the cut or fracture occurs by applying firm but fairly light pressure, with the spring doing most of the work. With practice, the choice of nipper for cutting each material becomes one of personal preference. Protective eyewear and dust masks are strongly advised at all times.

DEMONSTRATIONS
SHOWING THE VARIOUS
CUTTING TOOLS AND
SUGGESTED USAGE (II)

RIGHT: **Use aluminium
wheeled mosaic nippers to
cut from Venetian gold
plates.**

BELOW RIGHT: **Use wheeled
mosaic nippers to cut
vitreous mosaic glass tiles.**

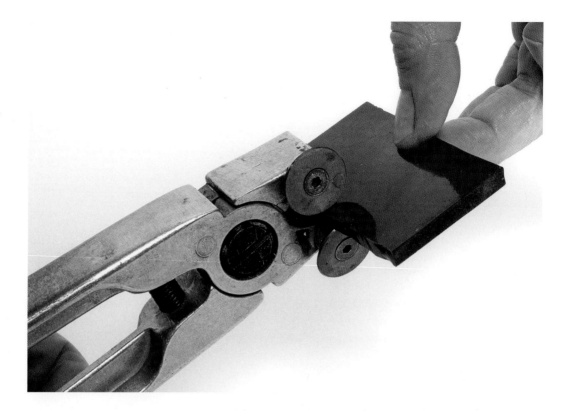

Grouting

All the grouting procedures featured use a proprietary ready-mix powder grout. Many manufacturers produce such a grout. Choose one based on grey Portland cement and incorporating a finely-ground sand. Any pigment added should be one suitable for permanently colouring cement. The grout is mixed with water only, to a fairly stiff consistency. This is rubbed into the surface interstices to strengthen the adhesive bond and to create the characteristic 'mosaic' look. Be sure to wear protective gloves at all times during the procedure. The mosaic surface is wiped clean using soft cloths and left to 'cure' under damp cloths or towels for two to three days. This is a chemical hardening process and requires damp conditions for the strongest concrete bonding to form. Any residual surface scum can be washed off with cold water alone or in conjunction with a proprietary mortar cleaner, where the directions should be carefully adhered to. Allow the finished work, when clean, to dry flat, to prevent any possible warping of the backing timber.

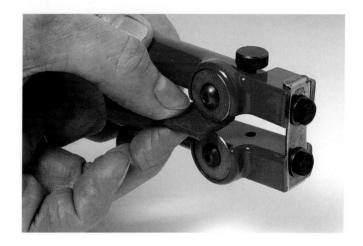

STOCKISTS

A good hardware store or building merchant will stock many of the mosaic materials needed to create the mosaics in this book, for example the mosaic nippers, adhesives, sealants and cement grouts. Many tile specialists will stock an amount of mosaic material, such as vitreous glass and ceramic mosaic tiles; some may stock marble cubes, too. They may also have unique selections of tiles with usefully glazed and gilded finishes. The specialist stockists below hold a wide variety of additional materials for advanced techniques and experimentation in mosaic work.

Source Stockists for Materials Used in this Publication

SMALTO (PL. SMALTI):
This sumptuous handmade material, unique to mosaic making, is bought by the individual plate or pizza, or can be cut to order. Smalti is bought by weight. There is a vast range of colour choice – deciding which to choose is the most difficult decision.

VENETIAN METALLIC GOLD:
A glorious material available in many colours – a variety of gold and white golds, plus superb colours, for example blue, turquoise, red, green. It can have a smooth, undulating or granulated surface. It is bought by the plate or piastra, 80mm × 80mm ($3^1/_2$ × $3^1/_2$in), or cut, 20 × 20mm ($^3/_4$ × $^3/_4$in) and 10 × 10mm ($^1/_3$ × $^1/_3$in) (all sizes for this hand-created material are approximate). It is purchased by weight.

MOSAIC HAMMER AND HARDIE (MARTELLINA E TAGLIOLO):
The specialist tools for cutting marble and smalti.

THE HAMMER:
This is a variously weighted tool. Choose one of comfortable weight for frequent wielding. It has two cutting edges, which should be kept clean and sharp for efficient use.

THE HARDIE:
This chisel has one long tapered end that is embedded in timber, and a slightly curved, very sharp, top on which to place the materials to be cut. Choose one suitable for marble or smalti.

Angelo Orsoni s.r.l.
Cannaregio 1045
30121 Venezia/Venice
Italy
tel: 00 39 (0)41 244 0002/3
fax: 00 39 (0)41 524 0736
email: info@orsoni.com
website: www.orsoni.com

RAVENNA MIRROR GLASS:
This highly coloured mirror glass for use in mosaic comes in a wide variety of rich colours with a number of finishes. It can be bought by the sheet, or in pre-cut pieces. Any amount can be bought. It is generally cut using wheeled mosaic nippers.

Anna Fietta
Via Argentario 5
48100 Ravenna
Italy
tel: 00 39 (0)544 213 728
fax: 00 39 (0)544 213 728
email: finelli@annafietta.it
website: www.annafietta.it

MARBLE:
There are two producers of cut marble for mosaic use. The marble can be bought in a variety of cubed sizes. The colours are wide and various. Marble is bought by weight.

Ferrari and Bacci
s.n.c. di Bacci e Bertellotti
Via Aurelia 14
55045 Pietrasanta (LU)
Italy
tel: 00 39 (0)584 790 147
fax: 00 39 (0)584 794 182

Tabularasa srl
viale scalo S. Lorenzo 40
00185 Rome
Italy
tel: 00 39 (0)645 420 272
fax: 00 39 (0)645 420 511
website: www.tabvlarasa.com

GLAZED CERAMIC AND METALLIZED CERAMIC TILES, MICRO-MOSAIC TILES:
These are colourful glazed and enamelled tiles, and metallic-surfaced tiles. The materials can be bought by weight and by the sheet.

Emaux de Briare (shop and museum of mosaic)
1 Boulevard Loreau
F-45250 Briare
France
tel: 00 33 (0)2 38 31 22 01
fax: 00 33 (0)2 30 37 00 89
website: www.emauxdebriare.com

Specialist Mosaic Stockists in the UK

The following stockists hold materials imported from the main sources abroad.

Edgar Udny: Smalti, Venetian metallic gold, vitreous glass tiles, ceramic tiles.

Edgar Udny and Co Ltd
314 Balham High Road
London SW17 7AA
tel: 00 44 (0)20 8767 8181
fax: 00 44 (0)20 8767 7709

Reed Harris London: Unglazed ceramic tiles, glazed tiles, marble and stone tiles, vitreous glass tiles, adhesives, cement grouts, plus a wide range of tools and materials. The vitreous mosaic tiles and ceramic mosaics are generally bought by the sheet. These need to be washed off and dried before use. A quick soaking in soapy water works well.

Reed Harris (main showroom)
Riverside House
27 Carnwath Road
London SW6 3HR
tel: 00 44 (0)20 7736 7511
fax: 00 44 (0)20 7736 2988
website: www.reedharris.co.uk

Reed Harris Wandsworth showroom (specifically for mosaics)
Unit 3, Sergeants Industrial Estate
102 Garratt Lane
London SW18 4DJ
tel: 00 44 (0)20 8877 9774
fax: 00 44 (0)20 8877 1577

INDEX